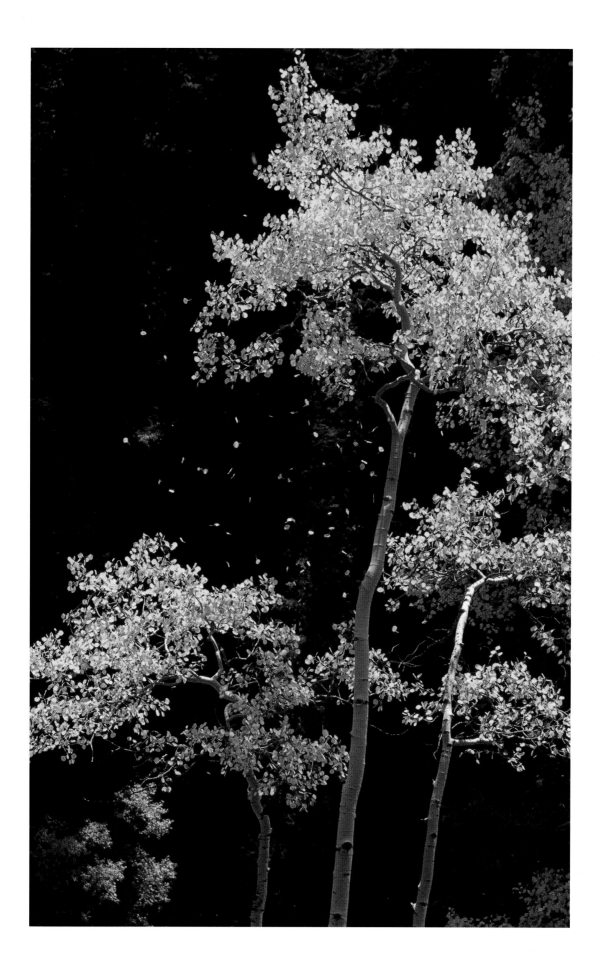

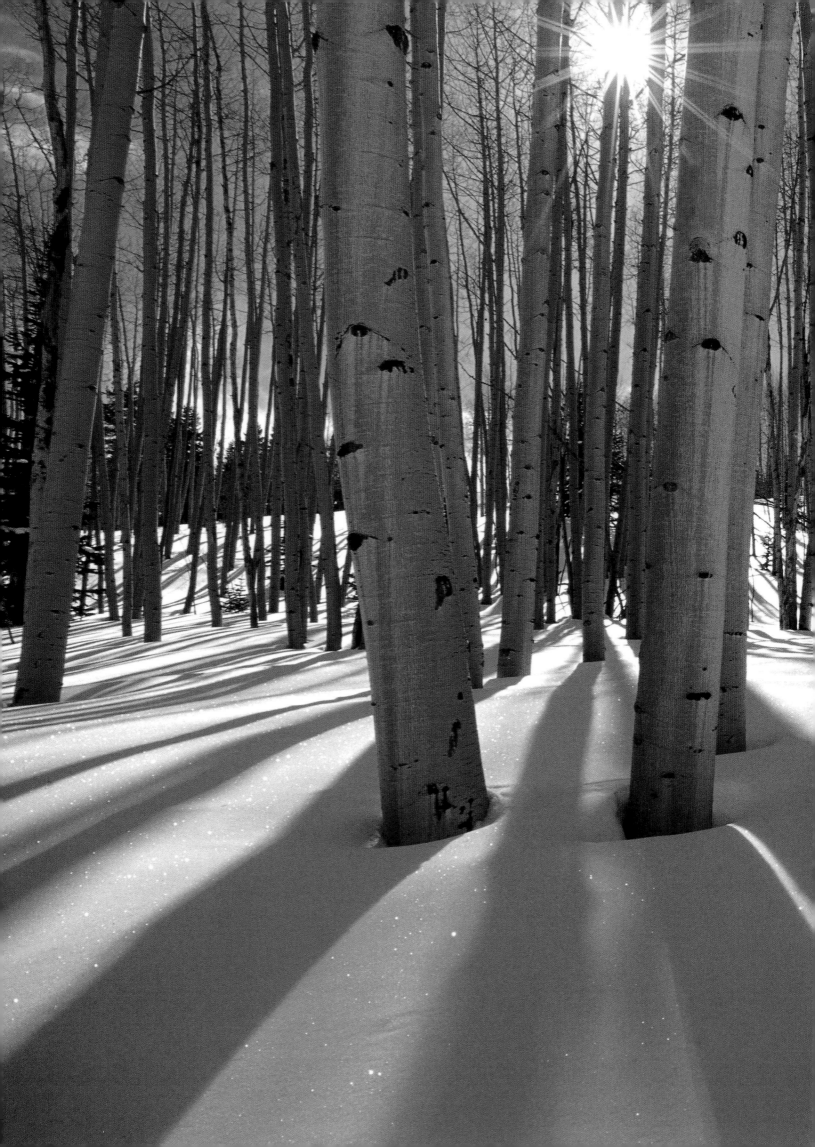

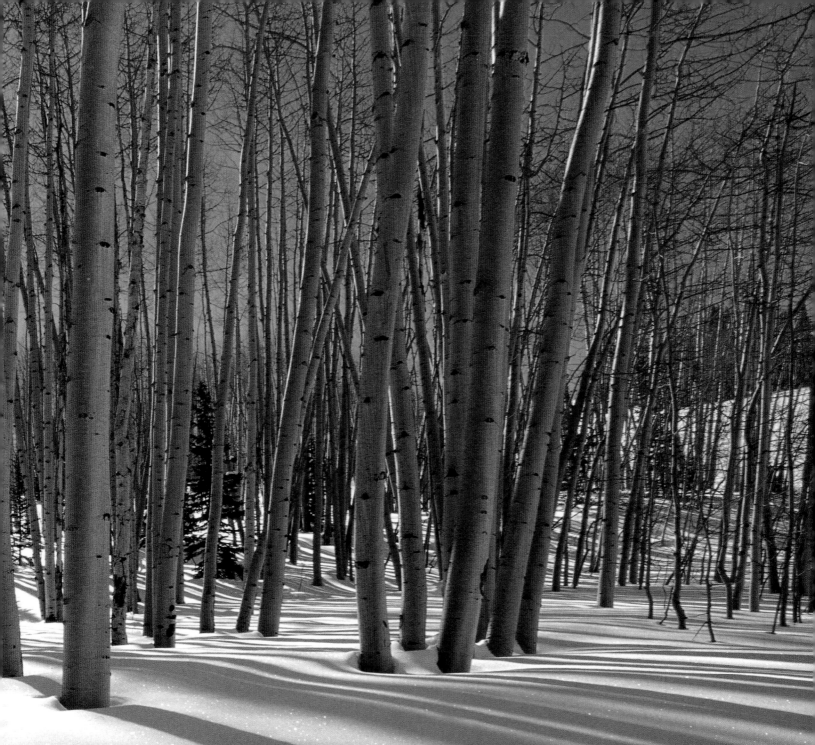

ASPEN: BODY, MIND & SPIRIT

Aspen: Body,

A PHOTOGRAPHIC

Mind & Spirit

CELEBRATION OF THE ASPEN IDEA

PHOTOGRAPHY BY BURNHAM
ALAN BECKER AND DAVID HISER
DESIGN BY CURT CARPENTER

W. ARNDT, AARON STRONG,
TEXT BY PAUL ANDERSEN
EDITING BY WARREN H. OHLRICH

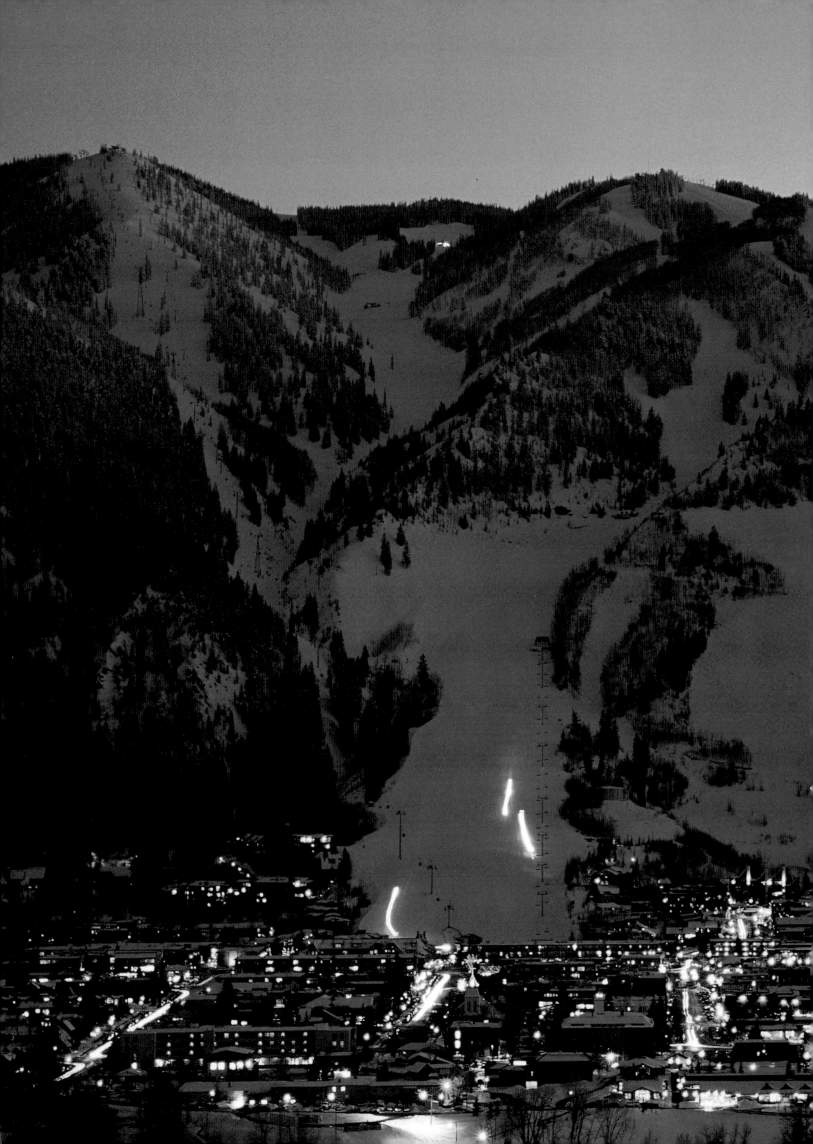

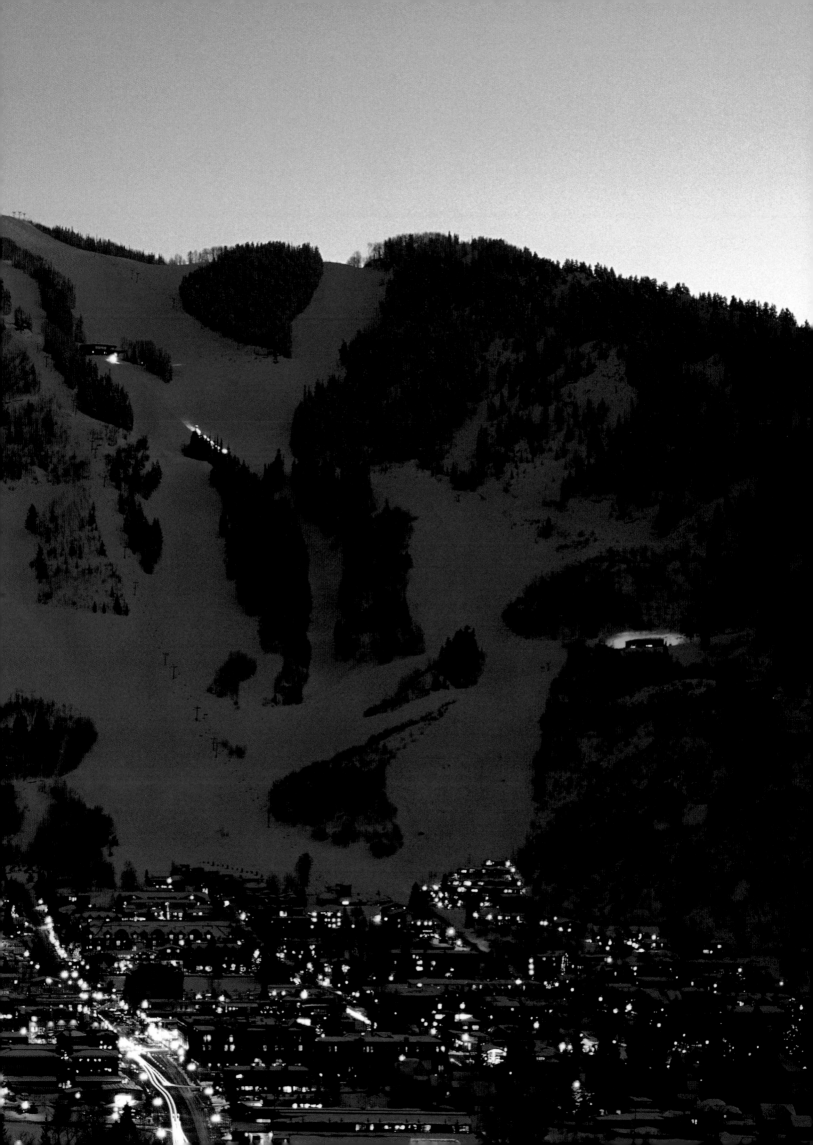

PUBLISHED BY

WHO PRESS
0311 West Sopris Creek Road
Basalt, Colorado 81621

©1999 by Warren H. Ohlrich

Text by Paul Andersen
Designed by Curt Carpenter
Edited by Warren H. Ohlrich
Printed in Hong Kong

PHOTOGRAPHER CREDITS

Burnham W. Arndt · ii-iii, iv-v, viii-ix, 1, 2, 8-9, 10-11, 12-13, 24-25, 35, 37, 40, 42-43, 45, 46, 47, 54, 60-61, 63 (BOTTOM), 70, 71 (TOP & BOTTOM), 72, 73, 75, 76-77, 80, 89, 90-91, 94-95, 97, 99, 107, 108-9, 112-13, 116-17, 118

Aaron Strong · i, 14, 16-17, 26, 27, 38 (TOP & BOTTOM), 39, 44, 49 (BOTTOM), 53, 67, 68, 78, 79, 81 (TOP & BOTTOM), 102-3, 104, 105, 106 (TOP), 106 (BOTTOM RIGHT), 110, 114-15

Alan Becker · vi-vii, 15, 18, 28-29, 30, 34, 36, 48, 49 (TOP), 50, 51, 52 (BOTTOM), 62, 66, 69, 74 (TOP), 82, 98 (BOTTOM), 106 (BOTTOM LEFT), 111

David Hiser · 7, 32-33, 41, 52 (TOP), 64-65, 74 (BOTTOM), 92-93, 100, 101 (TOP & BOTTOM)

Anderson Ranch Arts Center · 31, 98 (TOP)

Curt Carpenter · 63 (TOP)

Alex Irvin · 96

ISBN 1-882426-11-8
Library of Congress Catalog Card Number 98-94036

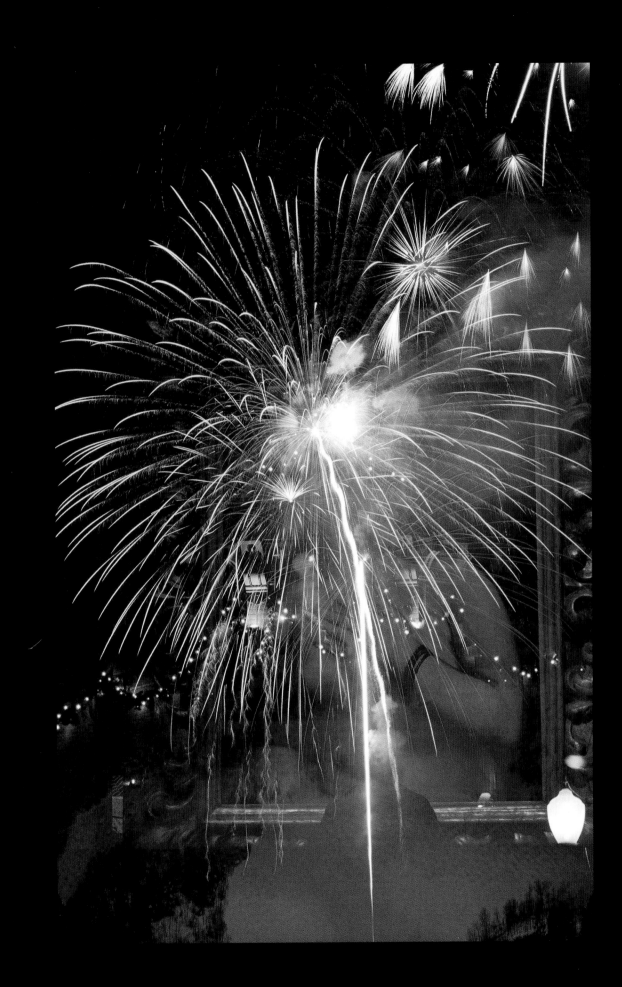

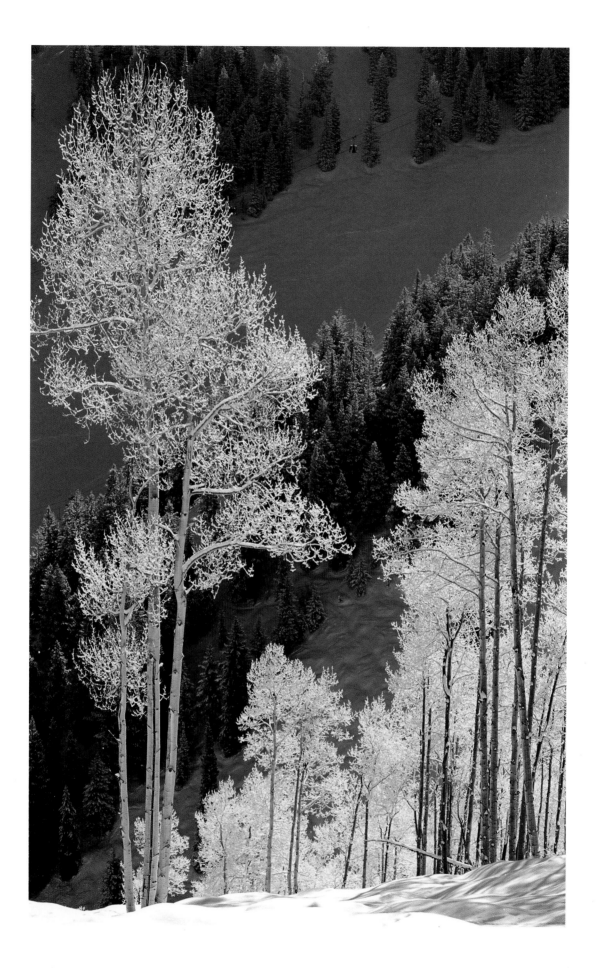

"Aspen is more than the sum of its parts.
It is a way of life, an idea."
—PEGGY CLIFFORD, 1974

ASPEN'S CULTURAL RENAISSANCE OF THE LATE 1940S was predicated on a keystone philosophy—the unity of body, mind and spirit. Coined "THE ASPEN IDEA" by its ambitious founders, this confluence of thought, creativity and action became the foundation on which Aspen evolved into a world center for recreation, music, art, literature, science and design.

THE ASPEN IDEA signaled the end of Aspen's "Quiet Years," those several decades following the Silver Crash of 1893 when Aspen was relegated to ghost town slumber. Shaking the town from its sleep, visionary Chicago businessman Walter Paepcke, for whom THE ASPEN IDEA serves as a sublime legacy, hoped to fashion a utopia.

Aspen would become a *Kulturstaat*, a civilized state organized around culture, and thriving on it. Only select disciples would be invited to buy property and take up residence. Through their esteemed influence these chosen few would elevate the dilapidated mining town beyond its already lofty 8,000 feet into a veritable Mount Olympus. Over time, Aspen would become the "Athens of the West."

Paepcke strove against all odds to bring THE ASPEN IDEA to fruition. But like most utopian concepts, it was overwhelmed by the prevailing culture. For Aspen, that culture was based on an emerging tourist and recreation economy—skiing.

Coupled with celebrity allure and a post-World War II revelry from the skiing elite of the Tenth Mountain Division, Aspen became a popular winter playground. The spell that had hidden Brigadoon in the mists of time was broken. Paepcke's ethereal, cloistered ideal was overrun by commercialism. The pure essence of THE ASPEN IDEA was compromised by the very elements Paepcke had, with futility, tried to hold at bay.

"Aspen was swept up in historic currents that brought the transition from industrial to postindustrial society, from a self-denying to a self-centered character type, and from modernist to postmodernist culture. . . . Aspen became an elite haunt favored by those seeking fashionable fun, searching for themselves, or hunting escape from routine lives," suggested James Sloan Allen in *The Romance of Commerce and Culture.*

THE ASPEN IDEA exists today as a high benchmark, a lofty potential. It serves as an historic influence whose broad brush strokes color Aspen's unwritten constitution with hues of idealism, culture, art, the intellect. THE ASPEN IDEA is illusive, abstract, and open to interpretation from adherents who have put their own spin on it.

Herbert Bayer, the acclaimed Bauhaus architect, ascribed the body/mind/spirit trinity to the source of creativity: "The creative process," he explained, "is not performed by

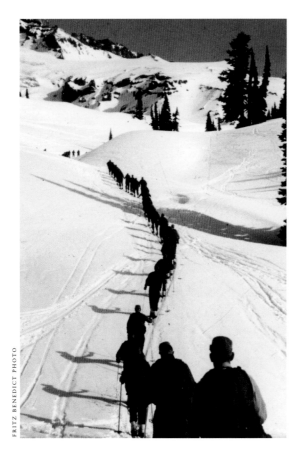

FRITZ BENEDICT PHOTO

The 10th Mountain Division during training exercises on Mt. Massive near Camp Hale in 1943.

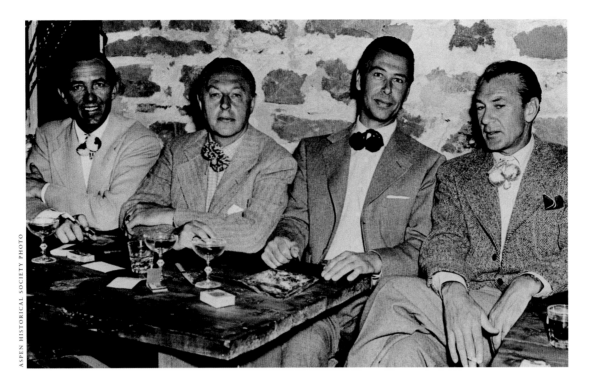

ASPEN HISTORICAL SOCIETY PHOTO

Ski School founder Freidl Pfeifer, visionary Walter Paepcke, artist Herbert Bayer, and actor Gary Cooper at the Four Seasons Club.

the skilled hand alone, or by intellect alone, but must be a unified process. Head, heart and hand must play a simultaneous role."

Walter Gropius, founder of the Bauhaus School, and one of Aspen's first and foremost second home owners, reflected on THE ASPEN IDEA from a mountain pass at 12,000 feet, overlooking the Maroon Creek Valley.

"I felt elated like a boy coming to your miraculous place and could not get enough of roaming about," exclaimed Gropius in a letter to Walter Paepcke. "I had a curious experience facing these great American scenes. First it makes one very humble standing on Buckskin Pass and looking from the mighty horizon to the flowers at one's feet; then these beautiful sensations transform into an incessant stimulus of which I hope to make good use."

Paepcke's vision was for an "American Salzburg," catering primarily to the mind, but tied to the physical component of skiing and the necessary income skiing would derive. "We don't want to

make Aspen a mass skiing center," cautioned Paepcke, "but rather have it fairly selective and just large enough to make it entirely profitable, but not overrun, especially on weekends."

Profitability through tourism—what Paepcke advocated in moderation—became the dominant drive for the burgeoning resort, where a playground frivolity competed with scholarly and artistic pursuits. In a festival atmosphere of contagious diversions, THE ASPEN IDEA was compromised. The "culture of narcissism" tainted the pure virtues.

Today THE ASPEN IDEA is little known, having faltered repeatedly in the face of Aspen's realpolitik. Though its roots were firmly planted in Aspen soil, the Idea is not widely broadcast or promoted. Idealism is not a mass market concept. THE ASPEN IDEA can still bloom with a surreal beauty, but only for individuals who choose to discover it on their own by synthesizing Aspen's varied offerings.

THE ASPEN IDEA is bold and presumptuous. It attempts to unify body, mind and spirit. It implies a harmony of man and the world around him. THE ASPEN IDEA is about closing the gap between divergent worlds in a setting universally appreciated as an esthetic ideal.

There may never be agreement on politics and land use, art and literature, design and development in Aspen, but there is agreement that something special thrives here. That something is THE ASPEN IDEA.

In 1949, at the Aspen Goethe Bicentennial, the great humanitarian Albert Schweitzer, on his first and only visit to the United States, proclaimed: *Aspen ist zu nach an den Himmel gabaut.* "Aspen is built too close to heaven." It's still mighty close to heaven for those who grasp a thread of THE ASPEN IDEA.

Aspen remains what Walter Paepcke first proclaimed it would be—"a place where the human spirit could flourish." This book hopes to convey and inspire the richness of Paepcke's dream.

The hulking mass and ragged profiles of fourteeners Pyramid Peak (left) and the Maroon Bells

...ight) are covered beneath a thick winter overcoat in this view looking south from Willow Basin.

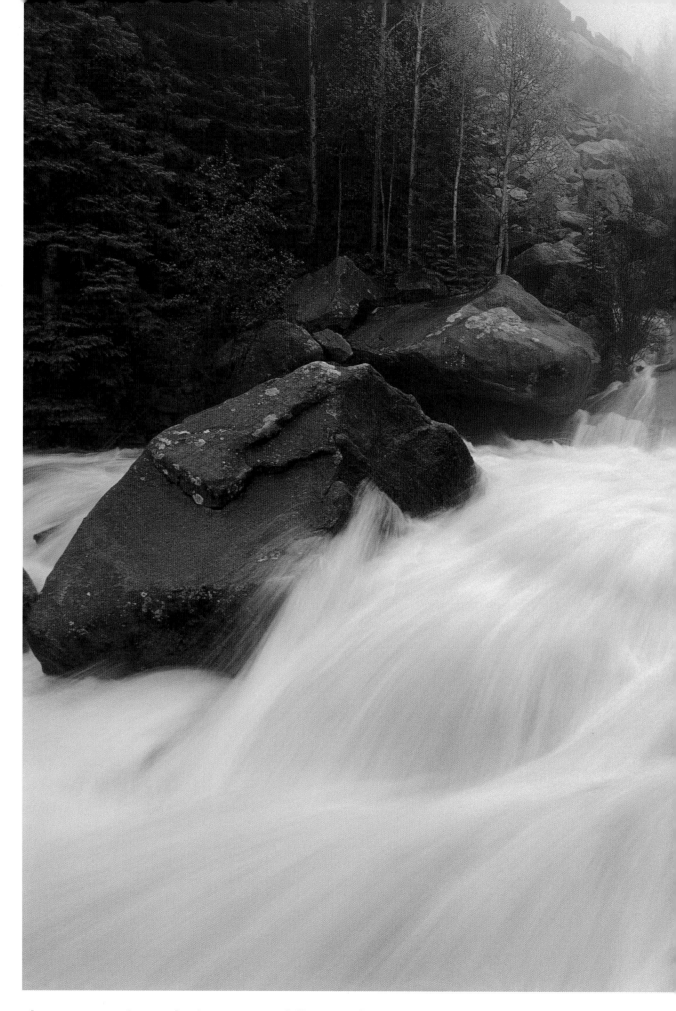

The upper Roaring Fork River roars in full spring flood with a voice of raw fury as it cascades

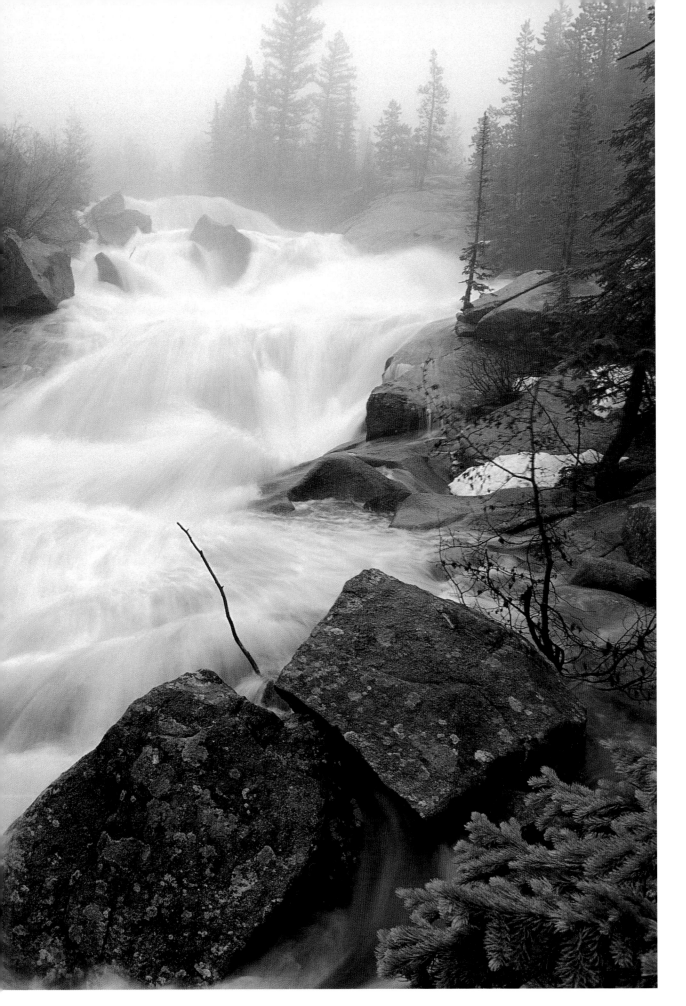

...hrough the Grottos on Independence Pass.

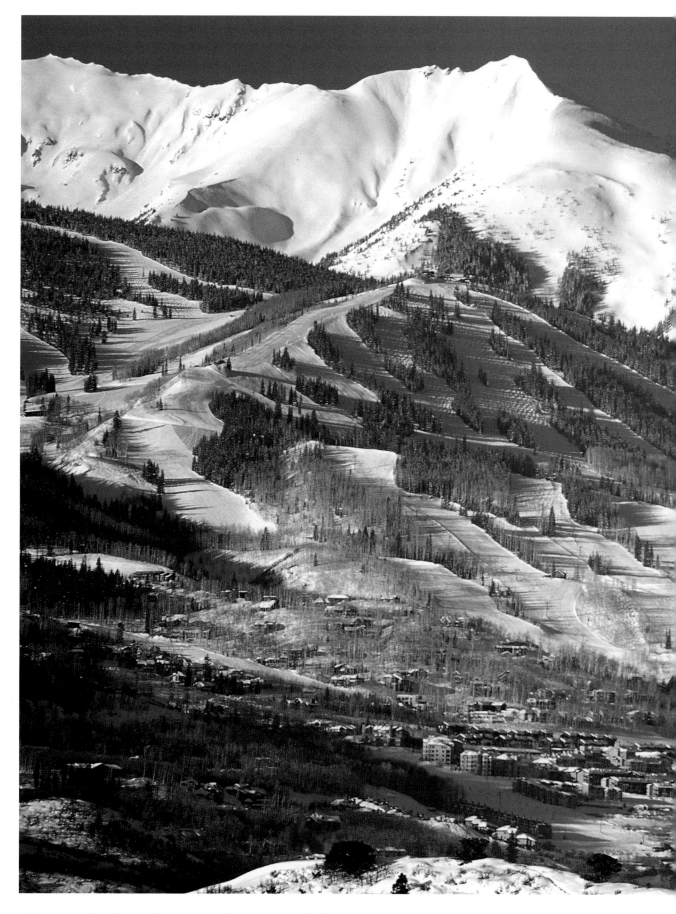

A Unicorn balloon rises in bright morning light above Snowmass Village with the ski runs of Sa

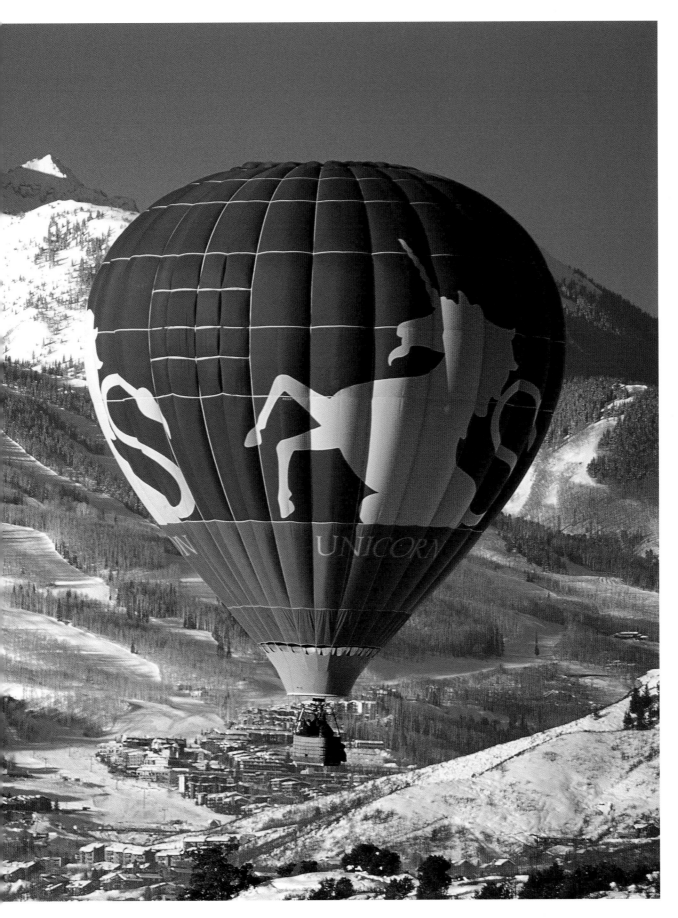

nob and the summit of Garrett Peak as a backdrop.

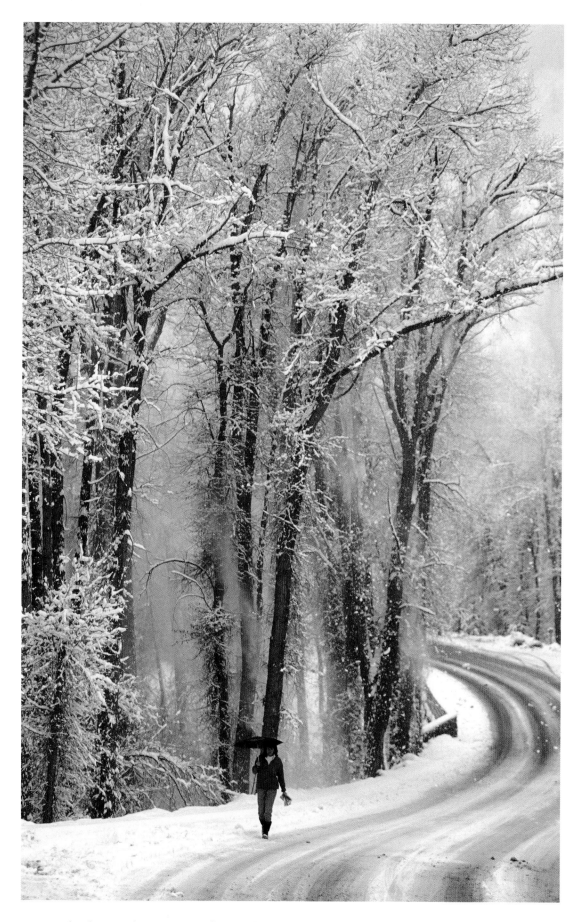

Aspen invites quiet contemplation beneath flocked cottonwoods . . .

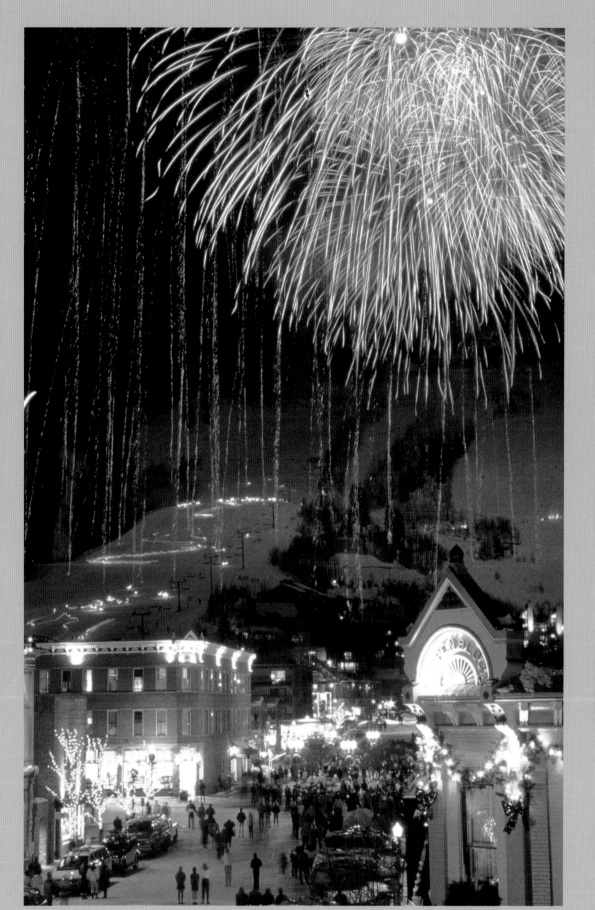

. . . or a pyrotechnic, carnival atmosphere during Wintersköl fireworks.

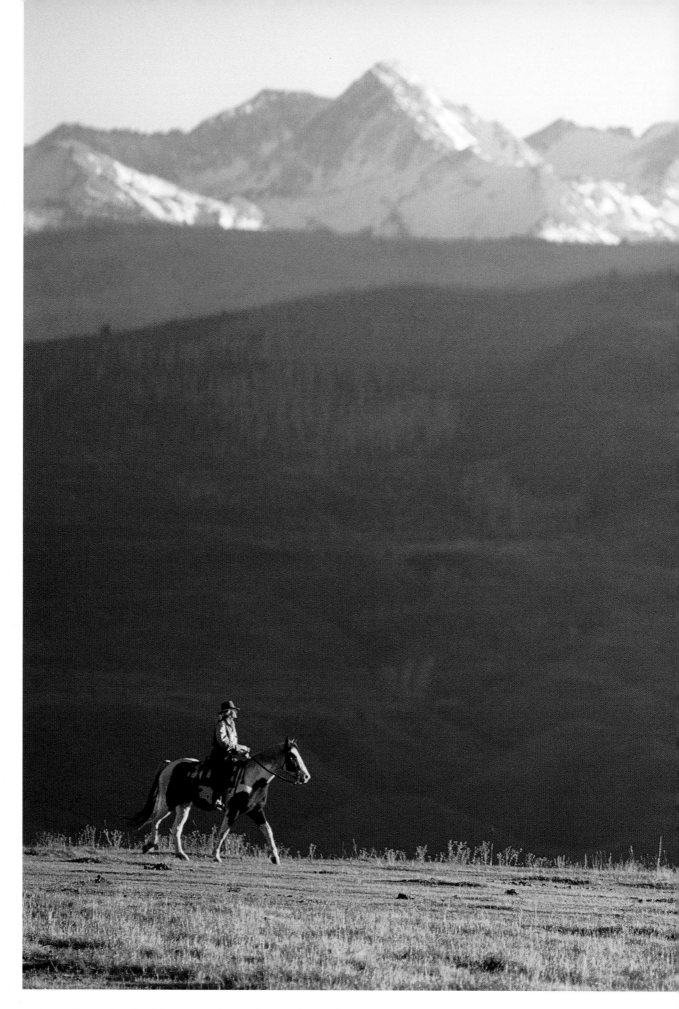

A lone horseback rider on Missouri Heights is humbled by the immensity of the Elk Range and t

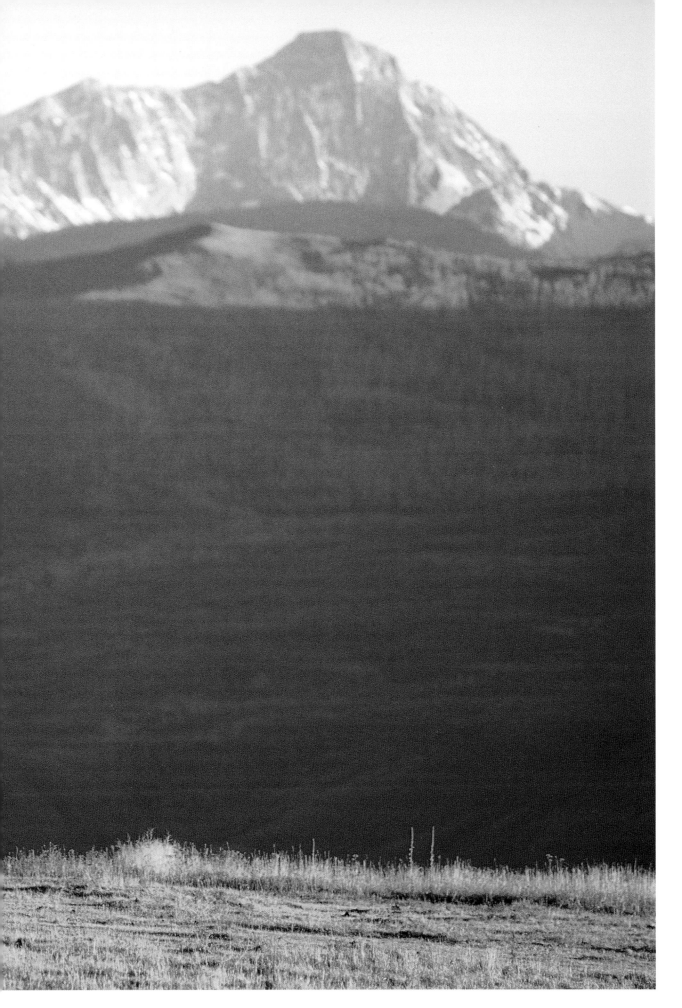

its prominent peaks—14,130′ Capitol Peak (right) and 13,300′ Mt. Daly (left).

*"Walter, you simply must see it!
It's the most beautifully untouched place in the world."*

—ELIZABETH PAEPCKE · 1939

WHEN ELIZABETH PAEPCKE FIRST SAW ASPEN IN 1939, it was because of skiing. Aspen wasn't much of a resort then, but there was Roch Run on Aspen Mountain and a jury-rigged ski lift made from an old mining tram. The Roaring Fork Winter Sports Club hosted Aspen's first race that year—the Southern Rocky Mountain Downhill and Slalom Championships.

The "body" of THE ASPEN IDEA was firmly established in Aspen long before the Paepckes and long before skiing. Silver mining in the 1880s and 1890s had defined it in breathtaking trails etched on steep mountainsides, smoothly contoured railroad grades curving along canyon walls, cavernous mining stopes hollowed from solid rock. Farming and ranching had cleared the land, established home-steads, and built a system of carefully engineered irrigation ditches. Introducing human scale and order to the wilderness was a physical ordeal. It required strong bodies.

The miners came for riches, the ranchers came for land, but Elizabeth Paepcke came for athletics. It was the body that first engaged her with Aspen, not the mind or spirit. What she discovered at the end of a long, rural highway was an enchanted relic, a bewitching hamlet, a place to strap on skis and plummet through soft, fluffy snow with hardly anyone else around.

Three decades of the "Quiet Years" had left a layer of grime

on old Aspen and a pall of quiet over her dirt streets, pot-holed and dusty. The city had an eerie museum quality, frozen in time by the Silver Crash of the previous century. For the wife of the visionary, Aspen was as enchanting as anything she had ever seen, and she was totally taken by it.

As Elizabeth Paepcke discovered Aspen, so each of us discovers something unique on the date of our first arrival. Chemistry, which so often describes the first meeting of lovers, is also the reason for attachment to place. There occurs a physical attraction of bodies, an emotional gravity that binds and holds.

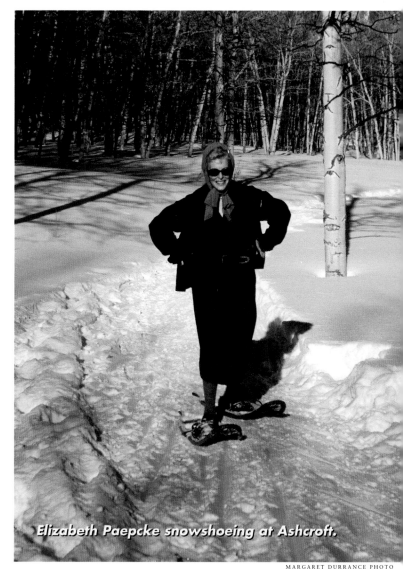

Elizabeth Paepcke snowshoeing at Ashcroft.

The "body" of THE ASPEN IDEA is many things to many people—a stunning mountain vista, an appealing architectural style, a particular ski run, a feeling of youth and vigor. Cumulatively, these influences merge into a magnetism that attracts us in a visceral, heartfelt way. We discover a connection to an atmosphere of town and mountains. We latch onto that first, magical feeling. We fall in love.

That's why Aspenites are so contentious about change. We fear that the delicate balance that has given us our rich experience could be altered, and with it our sense of belonging, our unique con-nection, our need for consistency. Physical surroundings are impor-

tant because they provide familiarity, comfort and nurture. The body of a place is the first thing we see and feel. It's natural to protect that first memory.

In Aspen, the body is most powerfully expressed by nature. The upheavals of geology, the carving of glaciers, the cutting of rivers, the natural progression of flora and fauna, all have created a spectacular montage. Nature's supreme force is in soaring mountains, whitewater rivers, towering forests, billowing thunderstorms, driving snow storms, blue sky and sunshine. It's in the smell of the air, the color of the trees, the light. The body of nature offers perspective and scale. It frames our worldly concerns with something ethereal, beyond the scope of man.

"At such altitudes everything was a little sharper, in clearer focus, a little nearer the sky," rhapsodized an Aspen Institute seminar participant in 1951.

"I have always been very susceptible to the greatness of Nature and to climatic glories," marveled German-born architect Walter Gropius. "My love for this country has noticeably grown in Colorado."

The mountains foster humility, awe, wonder and enchantment. They create a physical boundary, a rim of closure around Aspen, sheltering it from the sullying influences of the world. To some, the mountains are a mere backdrop to commerce, an image to adorn a brochure. To others they're a grand playground, a test for stamina, strength and athleticism. To others still, they inspire reverence, stewardship, adoration. How we interface with this splendid natural setting describes Aspen's diversity.

Skiers compete in the "24 Hours of Aspen" marathon, bombing down Spar Gulch at 60 mph in sub-zero temperatures, at night, beneath glaring lights, surrendering themselves to the heady pull of gravity. Hundreds of "uphillers" on skis and snowshoes defy that gravity in "America's Uphill." Extremes of physical activity

may range from a 10-hour climb of Pyramid Peak to a half-hour stroll along the Rio Grande Trail. There are no limits and no rules for individual gratification in Aspen's natural environment, just a standing invitation.

Mountain bikers pound over boulders and stream crossings on the Government Trail, the Sunnyside, Hunter Creek, Richmond Ridge. Paragliders pirouette 2,000 feet above the Northstar Nature Preserve after launching from Walsh's Run. Kayakers and rafters navigate the whitewater rapids of the Roaring Fork, baptized in icy currents. Rock climbers pump for a move on Turkey Rock or the Weller Dihedral. Mountain runners push their aerobic thresholds high in Montezuma Basin, over Buckskin Pass, or straight up Aspen Mountain. Skiers leave squiggles on the old mine dumps, waist deep in powder snow.

The "buff" body becomes a vehicle, a ticket to ride, an endorphin buzz. In Aspen, health clubs build muscles, physical therapists repair injuries, personal trainers conduct workouts, spas tone the skin, nutritionists prescribe diets. Fitness lends status as an expression of health and leisure. And if the fear of aging is too daunting, liposuction and plastic surgery cater to flab, wrinkles, vanity.

Hedonism is a sensitive word in Aspen because it's become part of the culture. The body is a focus, whether it's boogying on the dance floor in one of Aspen's nightclubs, cycling up Independence Pass, or scaling the Knife Edge ridge of Capitol Peak.

During the infancy of THE ASPEN IDEA, it was said that people came for the culture or for the skiing, but seldom for both. The seasons divided the attentions and interests of the town. Recreation co-opted the mind, and the mind condemned the frivolities of the body.

Today, much of Aspen embraces both body and mind. Physicists at the Aspen Center for Physics are among the most exu-

ROBERT CHAMBERLAIN PHOTO

Mathematical Foundation Rock at the Aspen Physics Institute.

berant mountaineers. Seminarians at the Aspen Institute explore local trails and enjoy workouts at the Meadows health club. Aspen Music Festival students and faculty hike Electric Pass and West Maroon Creek. Design conferees raft the Roaring Fork and Colorado rivers.

The fact that skiing and other recreational activities drive the economy in Aspen today suggests that the body has triumphed as the dominant part of THE ASPEN IDEA. In a place where the corporeal elements are so attractive, so vibrant and alluring, that should come as no surprise.

And yet, the unifying ideals of THE ASPEN IDEA exert a subtle influence. Despite what one historian disparaged as the "Janus-like character of Aspen," the divergent interests of body, mind and spirit are often unified here in a brilliant interplay of idea and action, thought and renewal. The body of THE ASPEN IDEA holds sway, but it needs the elements of mind and spirit to reach fulfillment.

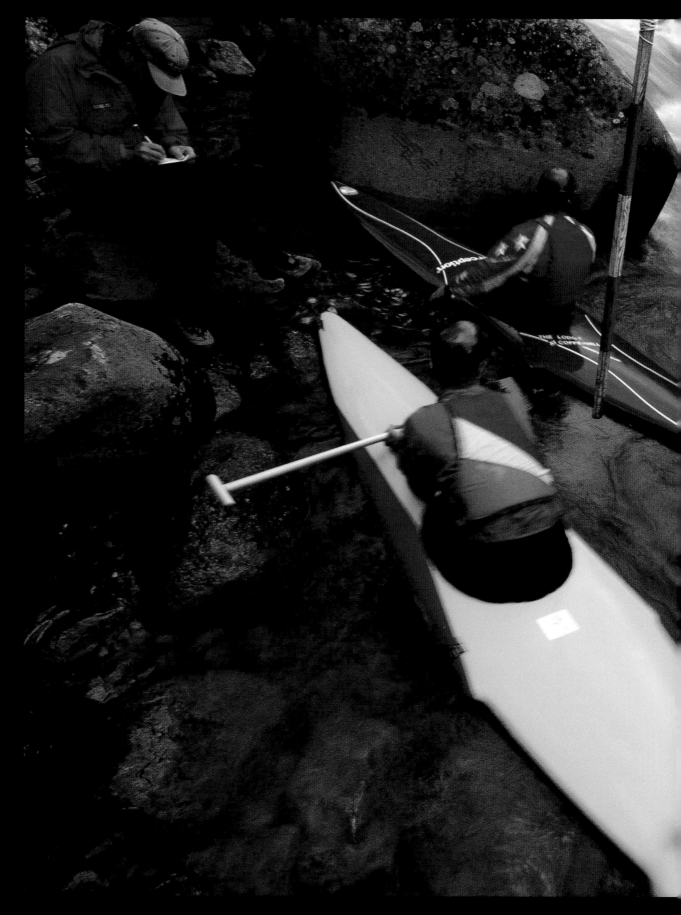

Playing with gravity, kayakers discuss the moves on a whitewater slalom course while resting i

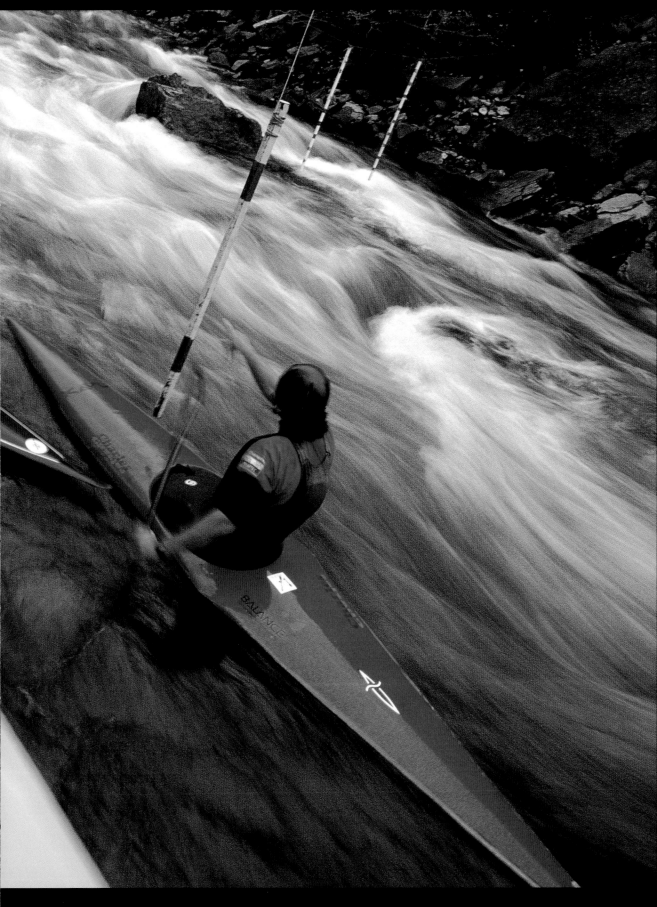

n eddy below Slaughterhouse Bridge on the Roaring Fork River.

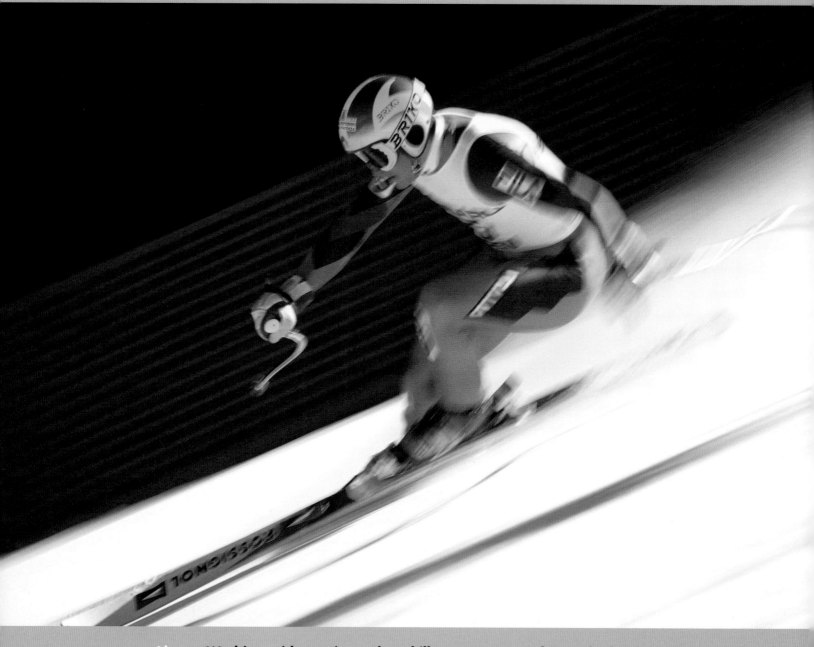

Above Working with gravity, a downhill racer sets an edge on boilerplate in a discipline of speed, daring, and split-second timing.

Right Challenging gravity, a woman rock climber, laden with chocks and carabiners, reaches for her chalk bag before attacking a pitch.

The pull of gravity is more than just a physical law.
It is an invitation to speed, a challenge to balance,
agility and judgment.

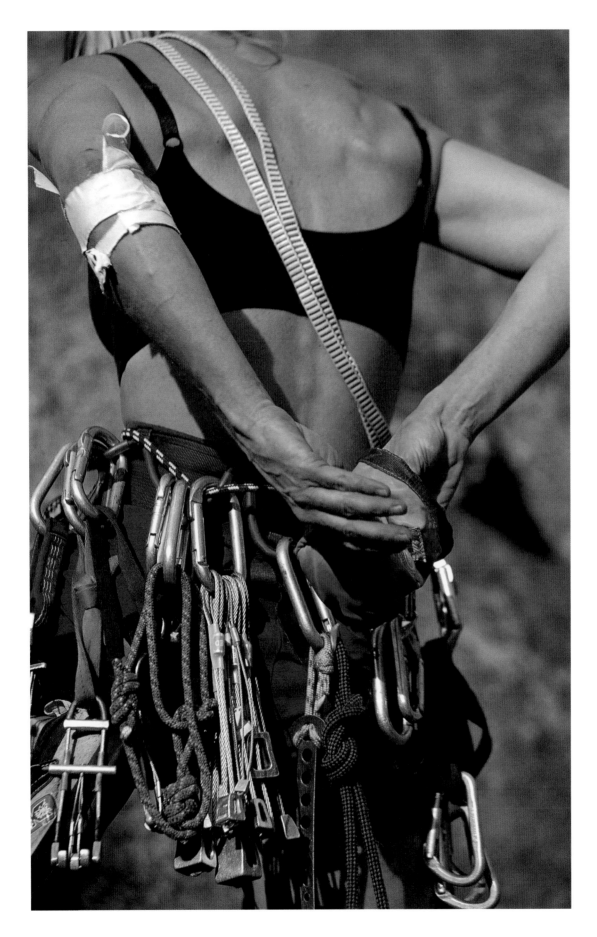

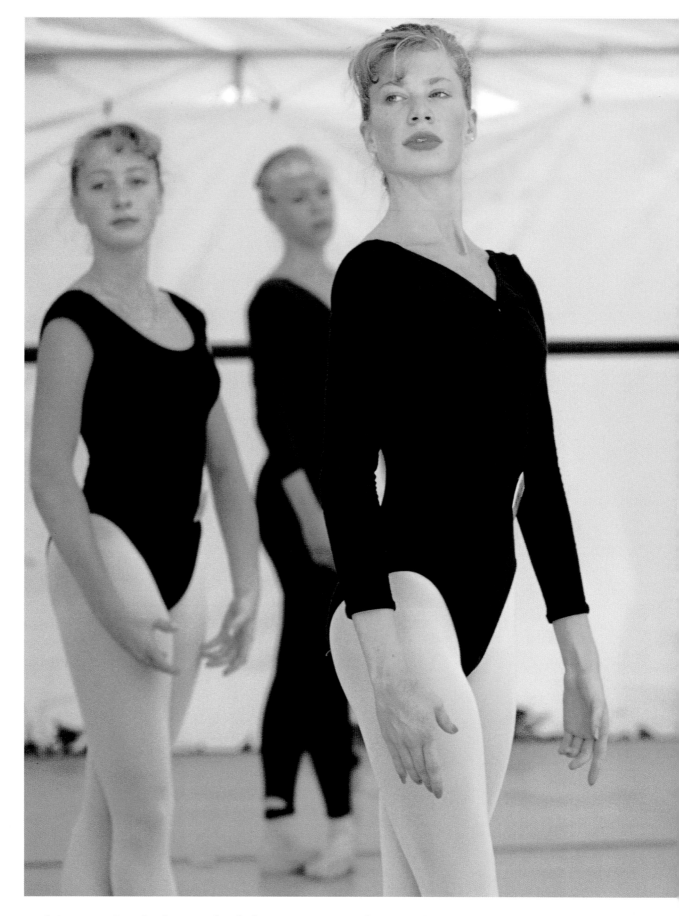

Defying gravity, the human body becomes an art form in the studied practice of ballet in Aspen.

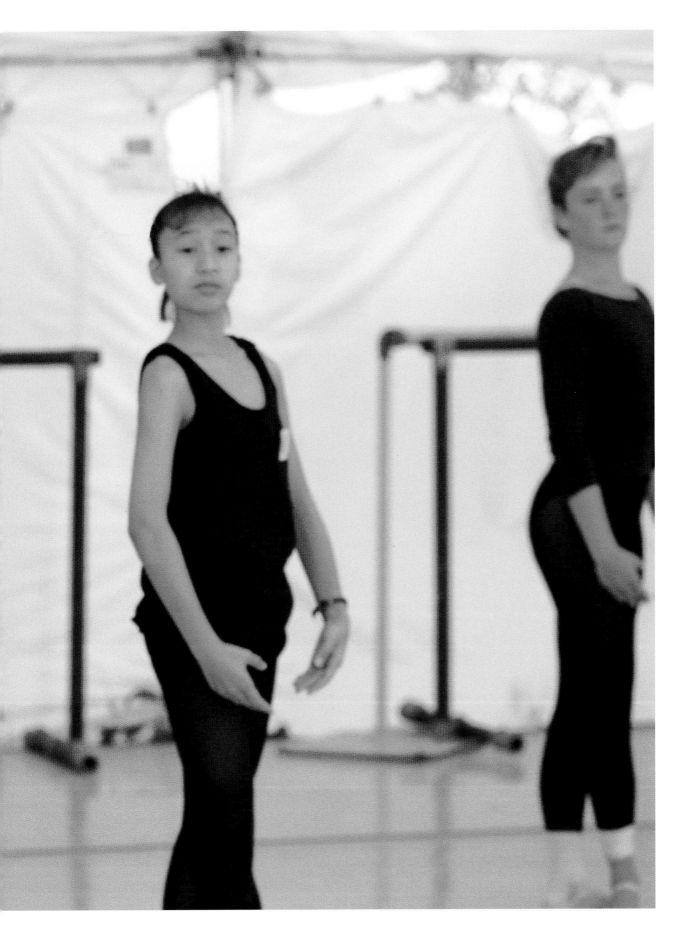

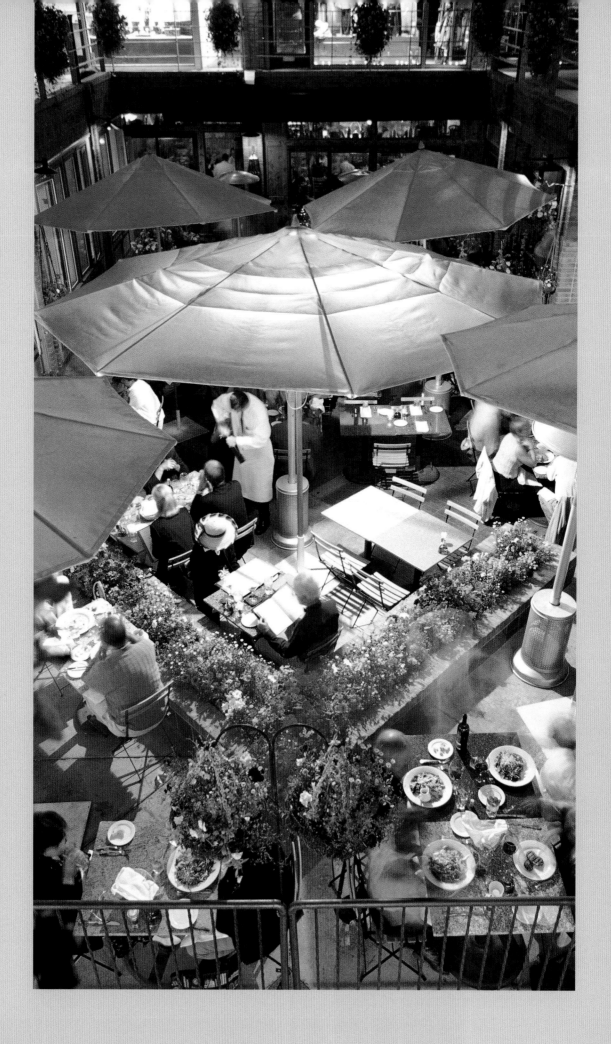

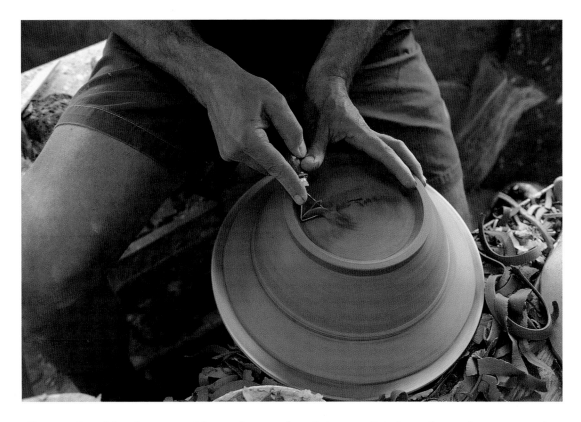

Above **Earthly clay provides a form of artistry as it takes shape in a potter's skilled hands at Anderson Ranch in Snowmass Village.**

Left **In Aspen, nourishment becomes an epicurean expression of refined tastes.**

Handicraft and art are a means for the body to apply a creative force and learned skill, imbuing the individual in the making of something from a raw element, whether it's clay, a wilderness valley, or a block of wood. The creative force is one of the most powerful incentives for man to grasp a dream.

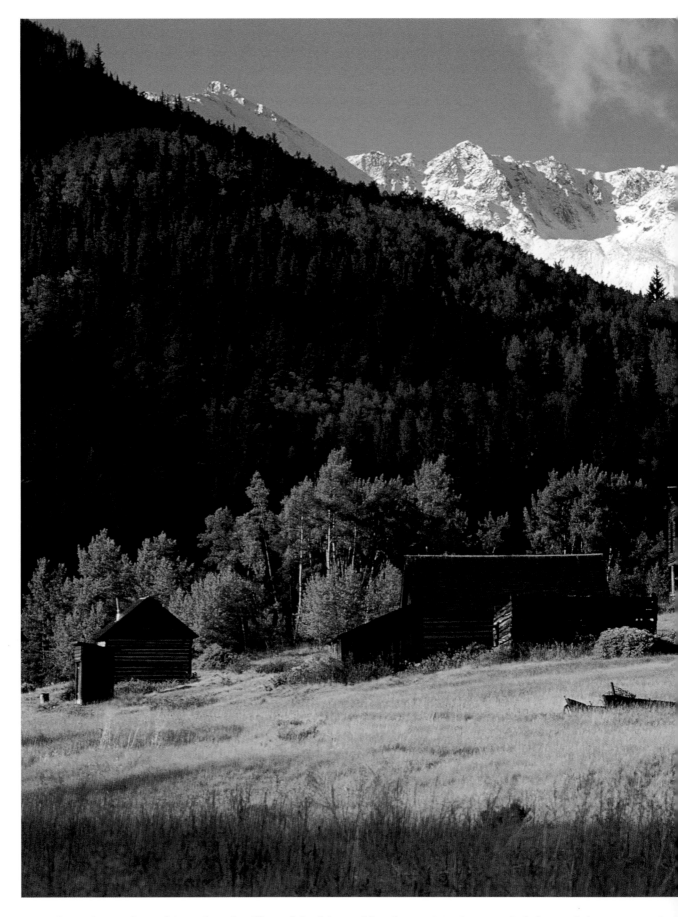

Rough timber, planed in a local mill and fashioned in the 1880s into a thriving mining camp, ha

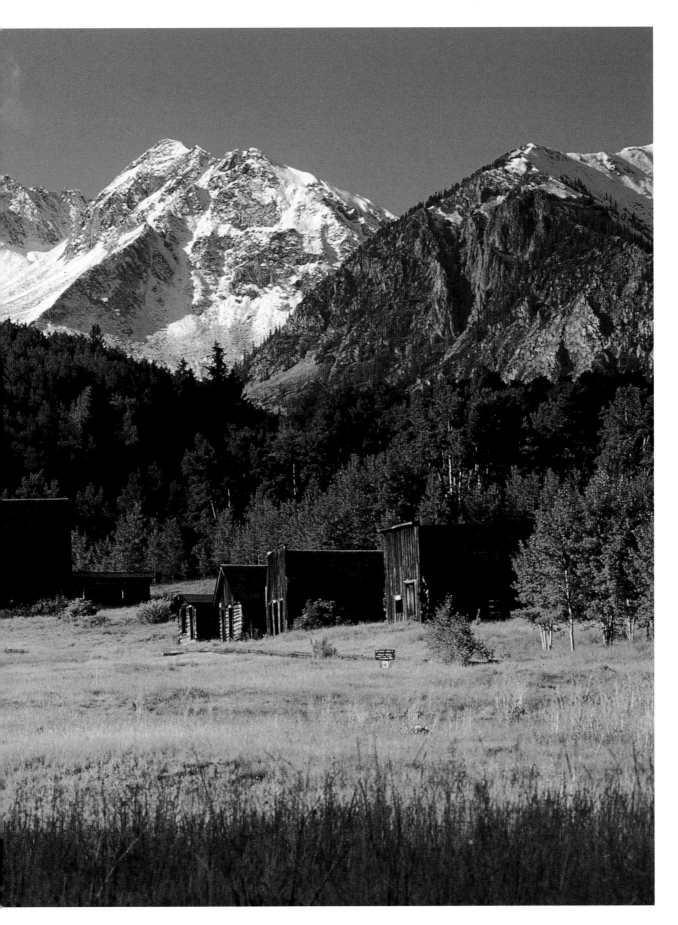

...ithstood more than a century of wear and tear at 9,500' in the ghost town of Ashcroft.

In Aspen's early days, wooden skis for transportation and sport were often homemade as a cottage craft.

Today, a different set of skis is available for every imaginable snow condition, or to color coordinate with a particular ski suit.

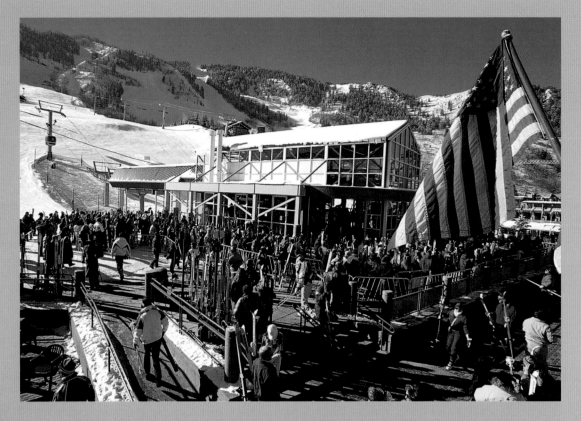

Above The "Silver Queen" gondola, given the nickname of ore-rich Aspen Mountain, opened in December 1986 and dramatically changed the scale and speed of skiing, especially when compared to the modest single chairlift that opened forty years earlier.

Right Speed and vertical skiing records have fostered an annual event since the late 1980s as competitors in the "24 Hours of Aspen" challenge their strength and endurance as they race around the clock for the most top-to-bottom runs on Aspen Mountain.

When the Aspen Skiing Corporation opened its first chairlift in Aspen in 1947, it was to complement the more important task of developing the intellect. Inevitably, skiing eclipsed the intellect as a primary passion. The body won over the mind. Skiing became Aspen's purpose.

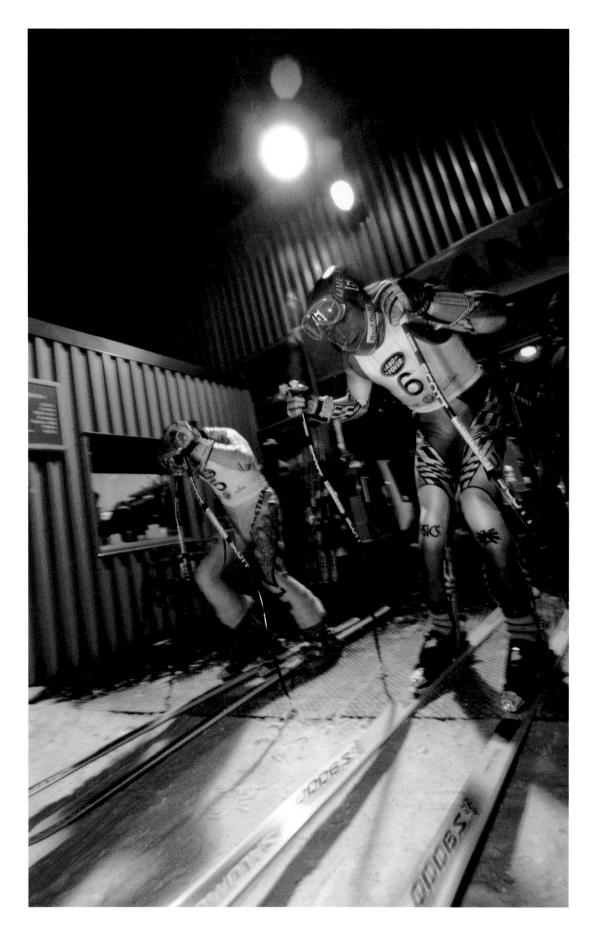

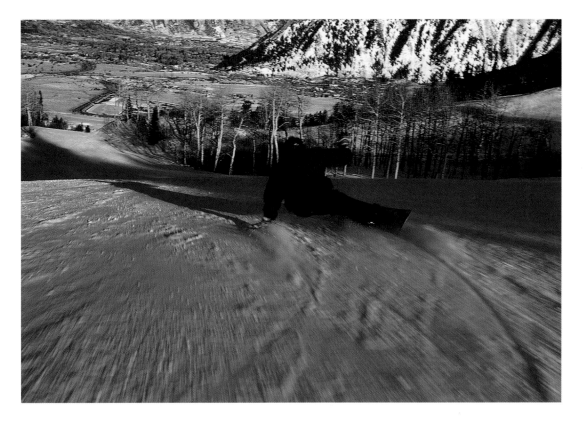

Smooth carving on a snowboard shows how weight, balance, finesse and speed define a graceful arc.

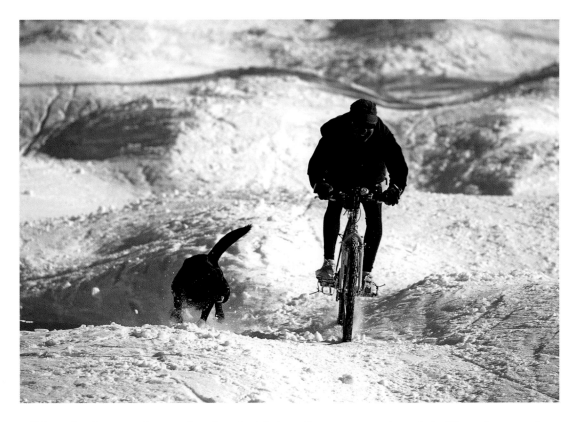

Biking the bumps is not for the timid, just for an occasional thrill seeker and his best friend.

The bumps of Bell Mountain on Aspen Mountain create a rugged texture and a sublime vertical playground for skiers in the fall line.

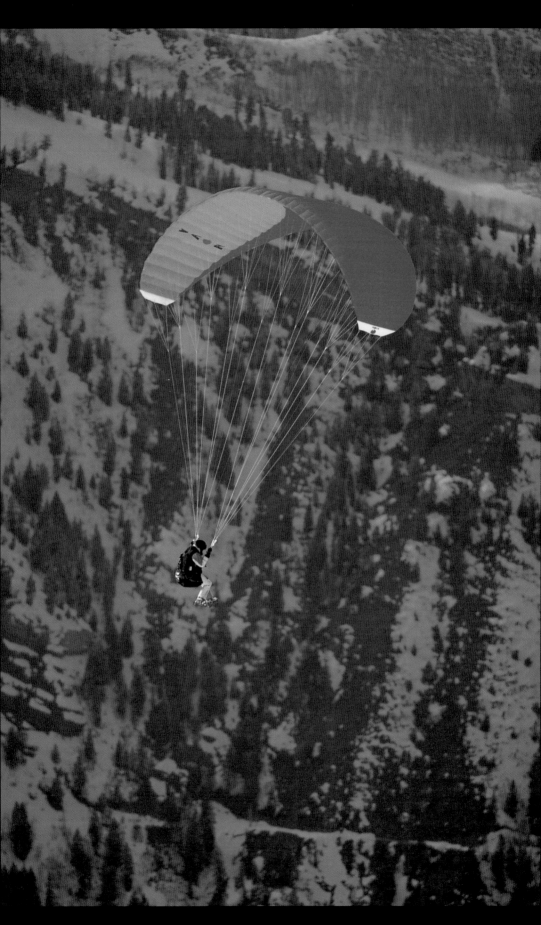

Paragliding combines a rush of speed, a roar of wind, and a rare exhilaration born of flight as the body pendulums beneath a billowing canopy.

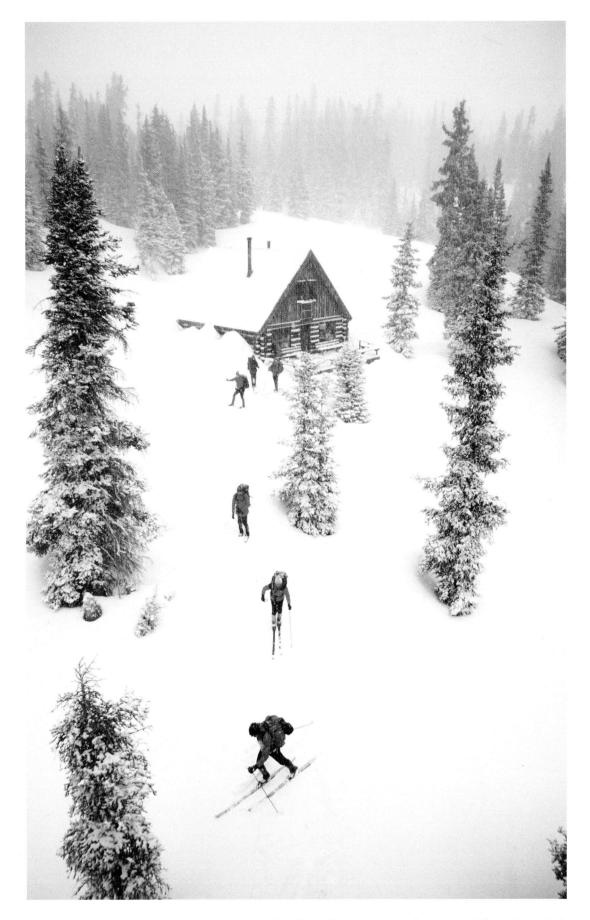

The dues of skiing six hours with a backpack are more than repaid at the 10th Mountain Division Margy's Hut with a convivial ambiance and as many deep powder turns as one can make.

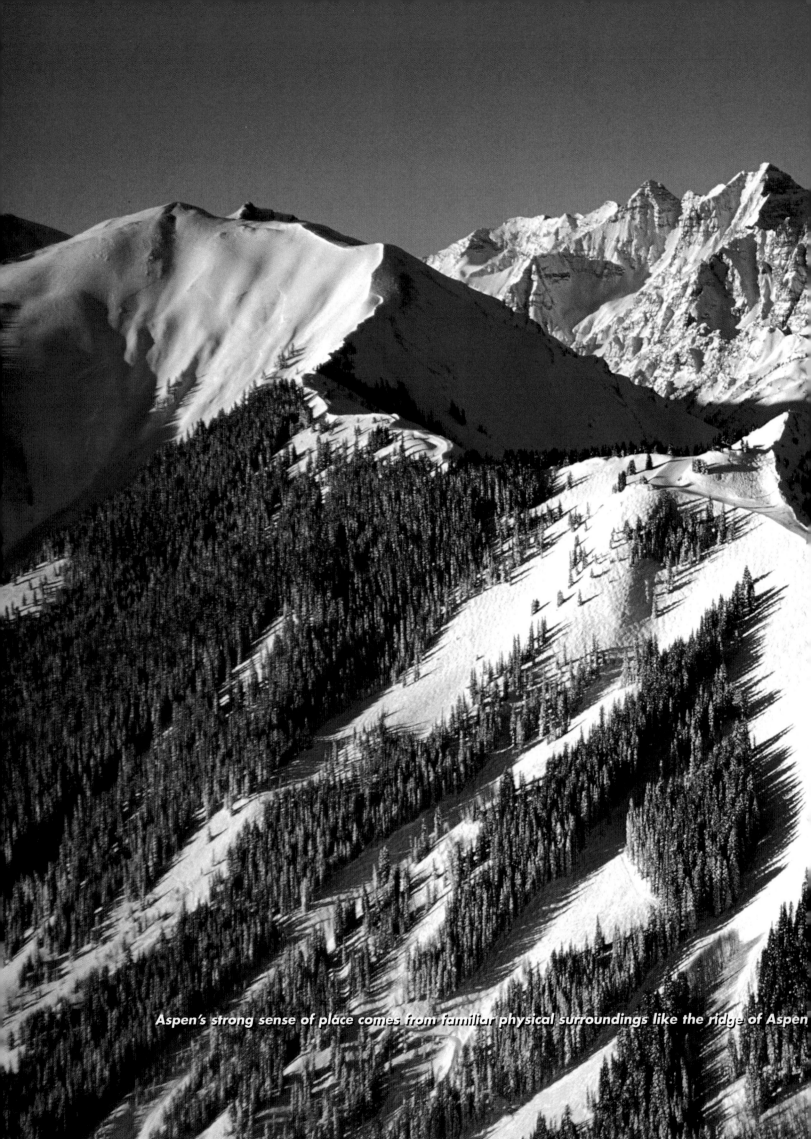

Aspen's strong sense of place comes from familiar physical surroundings like the ridge of Aspen

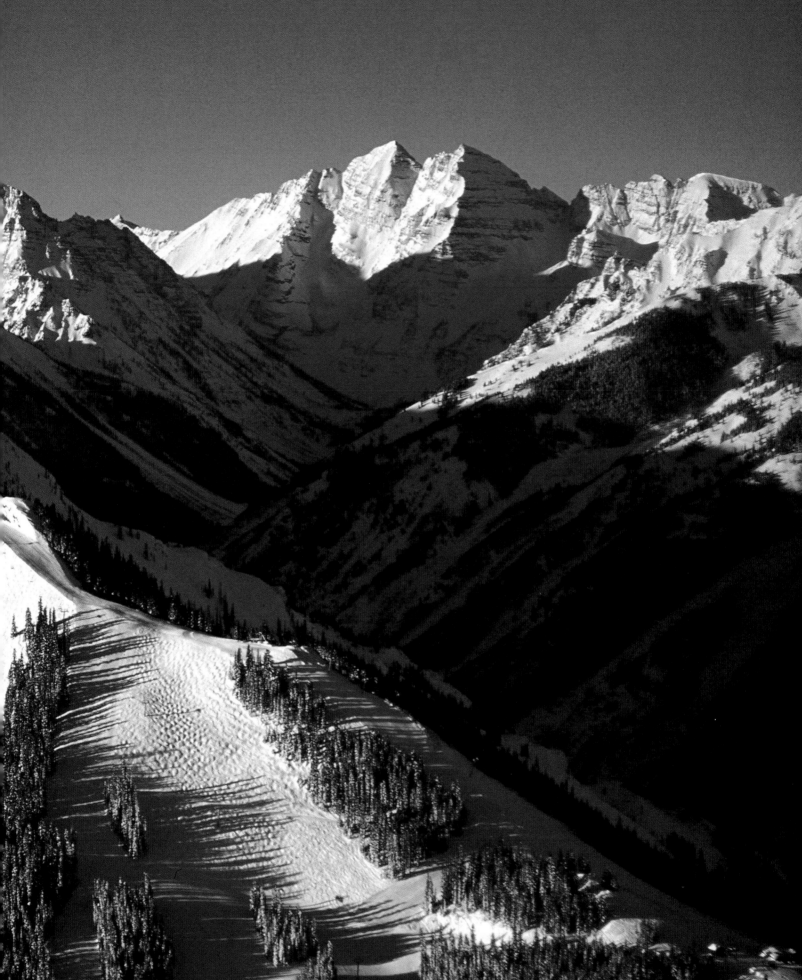

Highlands, the runs of Steeplechase, Highlands Bowl, Pyramid Peak and the Maroon Bells.

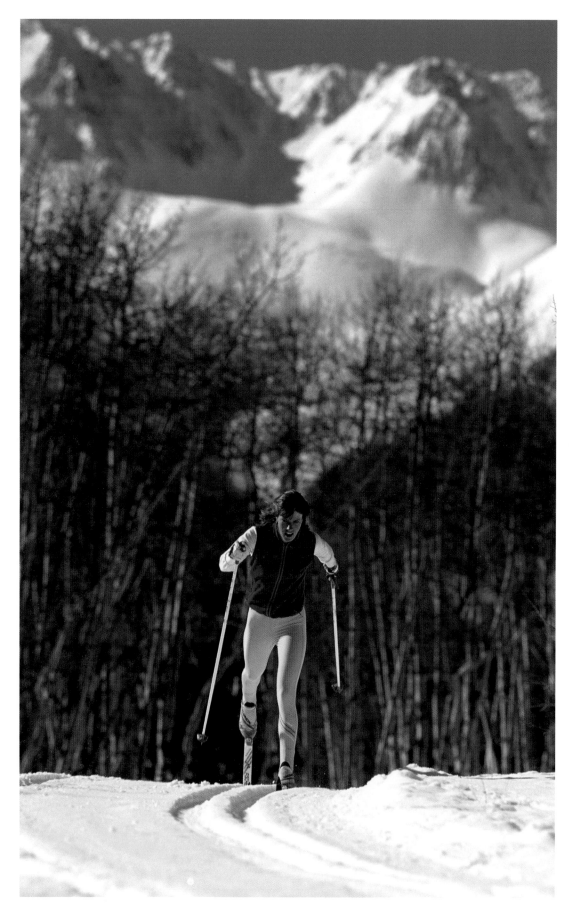

Seasonal transitions include a kick and glide session at Ashcroft . . .

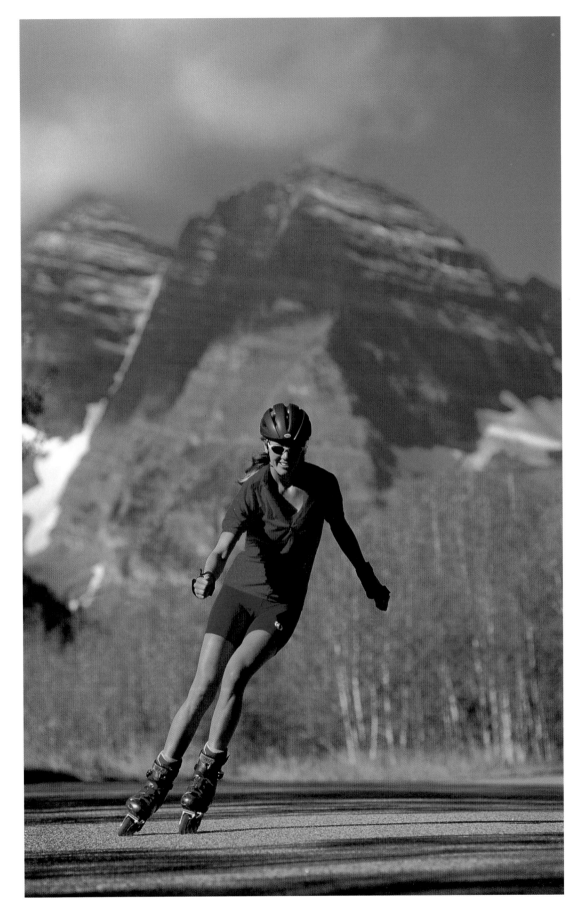

...and inline skating on the Maroon Creek Road beneath the "Bells."

The "buff" body becomes a vehicle, a ticket to ride,
an endorphin buzz. We nurture the body, we train it,
and it transports us into another realm.

Right **Swoop a turn on freshly groomed corduroy.**

Below **Surf a wave of snowmelt in a roaring river.**

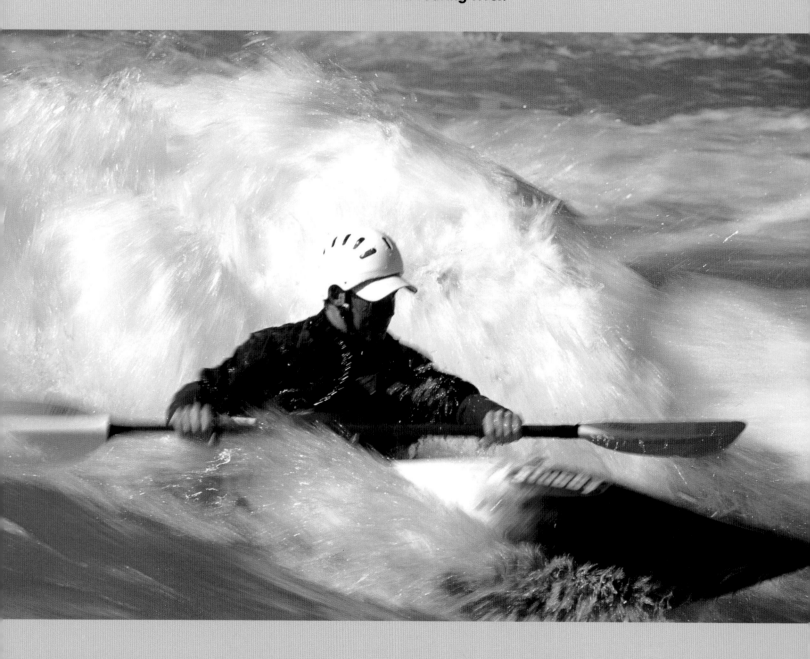

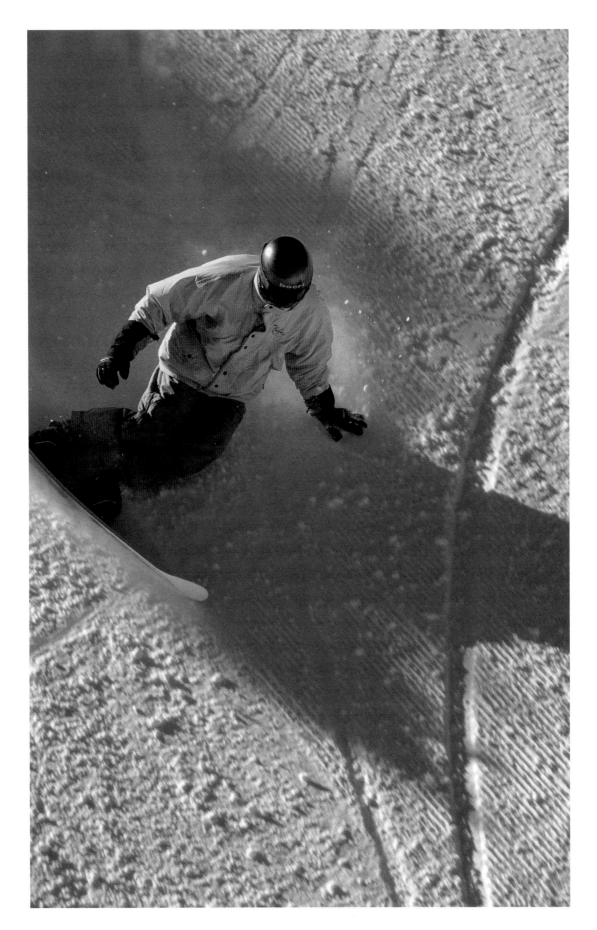

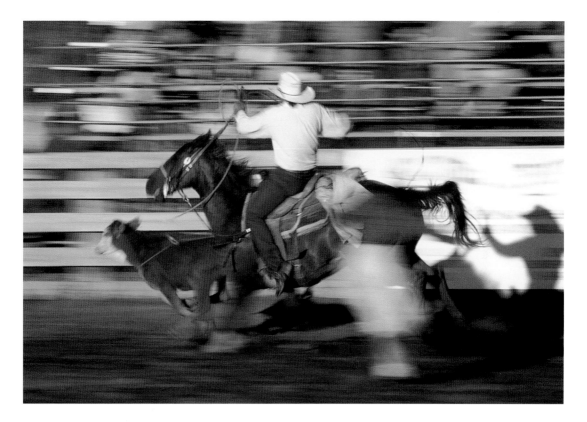

Summer rodeos at Snowmass Village show off a cowboy's panache and working skills.

To some, nature is a mere backdrop to commerce, an image to adorn a brochure. To others it's a grand playground, a work place, a test for stamina, strength and athleticism. How we interface with our splendid mountains describes Aspen's diversity and destiny. There is a lot to be gleaned from the games we play.

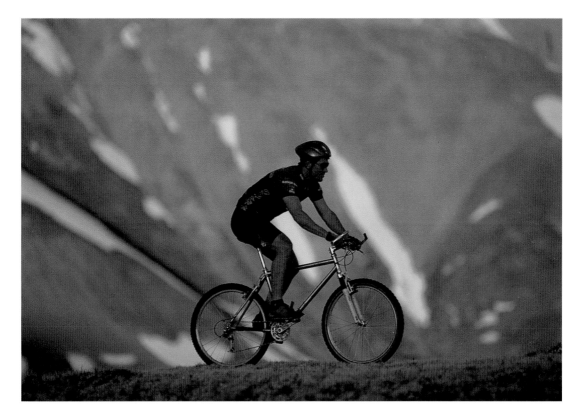

Mountain biking means a non-motorized, endorphin-charged pump to the backcountry.

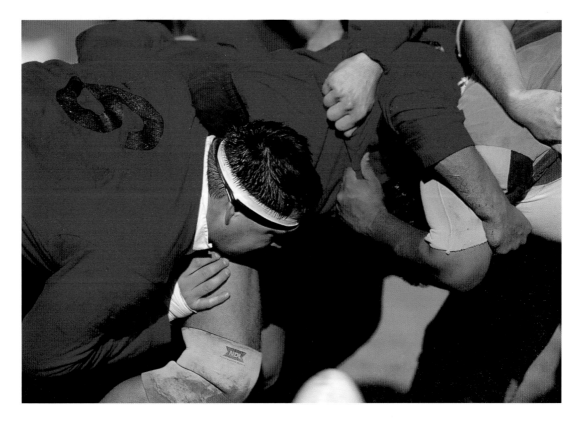

There is nothing more physical than burly, athletic ruggers in a scrum.

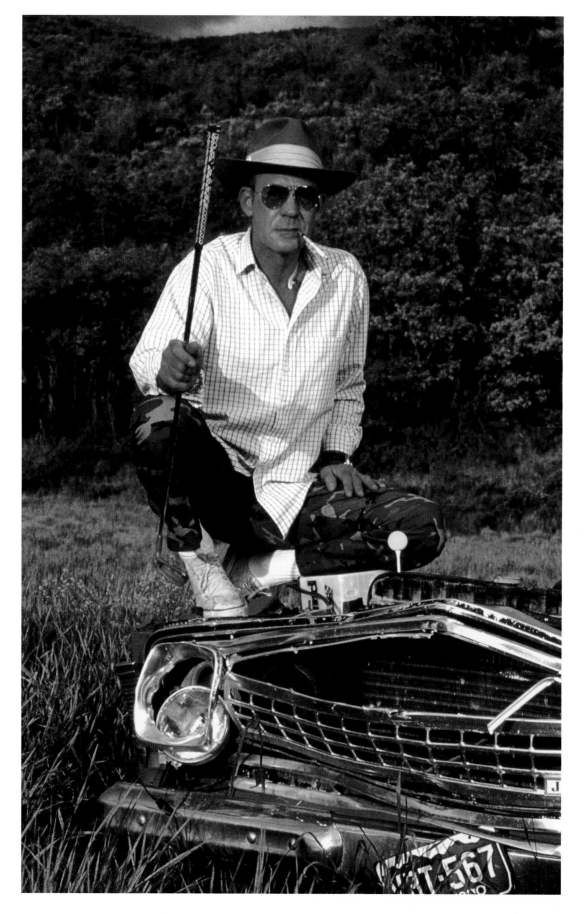

"Doctor" Hunter S. Thompson shows how rough the rough can be in Aspen . . .

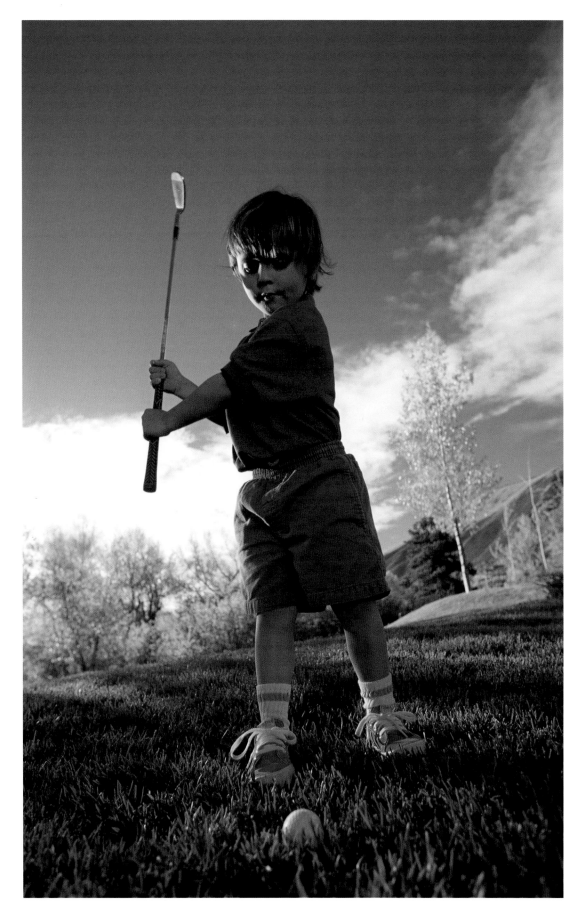

. . . while a young golfer winds up for an iron shot.

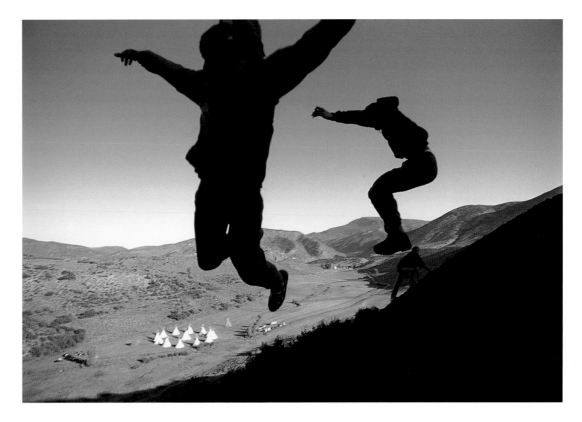

Life is to be celebrated, as Native Americans leap for dawn at Windstar.

A child's sense of play is spontaneous, all-consuming, and contagious.

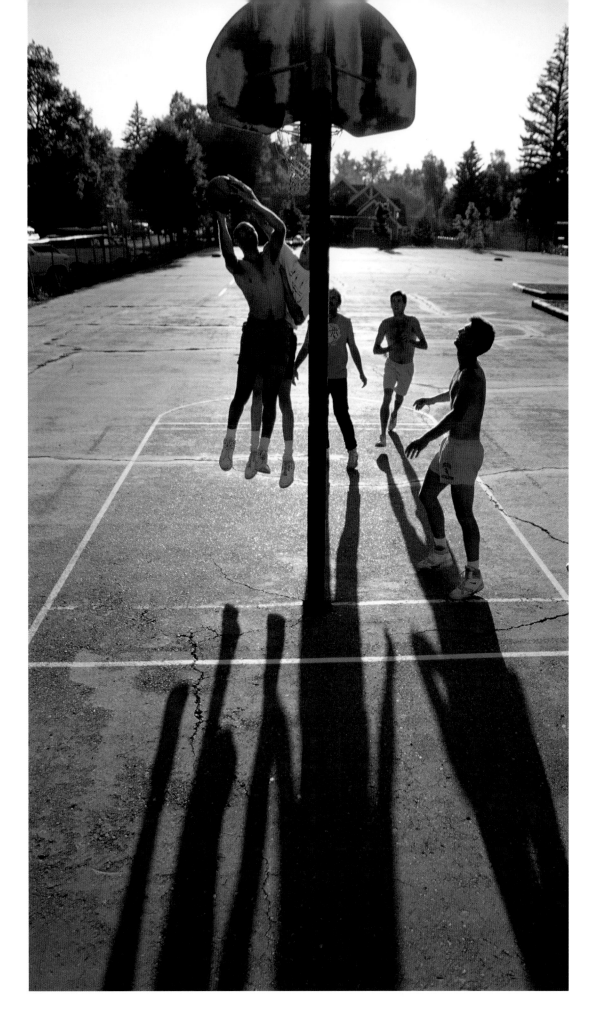

Hoop dreams are born at the Yellow Brick School yard in Aspen.

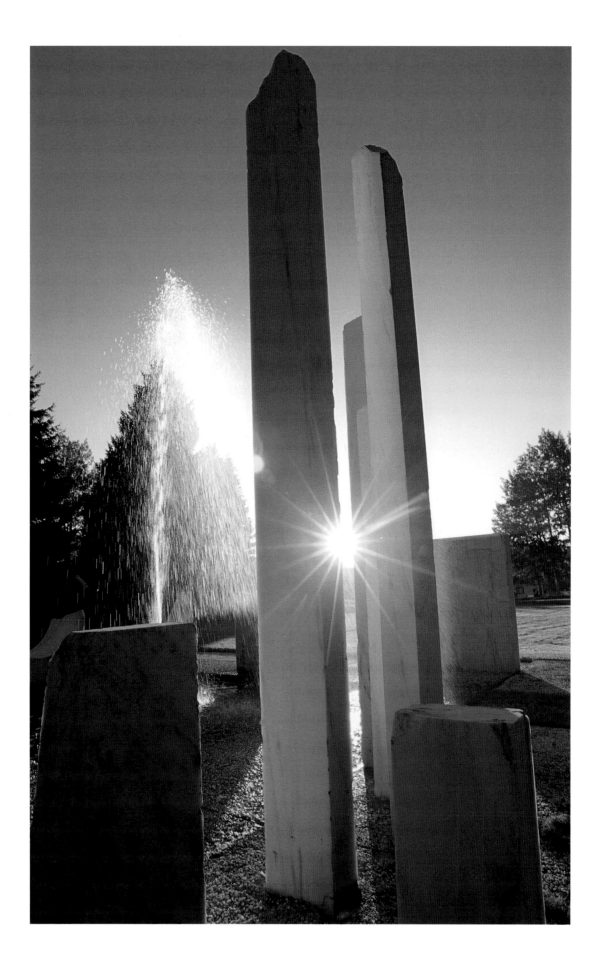

*"Since we came together so miraculously,
let us not lead a trivial life..."*

—JOHANN WOLFGANG VON GOETHE, *"WILHELM MEISTER"*

ROBERT MAYNARD HUTCHINS AND MORTIMER ADLER were among the key architects of Aspen. They weren't of the Bauhaus School, and they didn't draw blueprints. Instead they designed a virtual university in the mountains that became, in 1950, the Aspen Institute for Humanistic Studies. As close friends of Walter Paepcke, Hutchins and Adler developed the cerebral side of Aspen with what one historian described as "bookish and inevitably elitist cultural ideals." Hutchins was Chancellor of the University of Chicago, where Adler held a chair in the Department of Philosophy. Together they conspired to tear the blinders off unenlightened American businessmen and open their eyes to the brave new world of ideas and humanistic values.

An early mission statement from the Aspen Institute proclaimed its goal: "For American business leaders to lift their sights above the possessions which possess them, to confront their own nature as human beings, to regain control over their own humanity by becoming more self-aware, more self-correcting and hence more self-fulfilling."

Adler and Hutchins were men of the mind, staunch academicians who made no secret of their disdain for athletics. To them, the "body" of THE ASPEN IDEA was a base but necessary evil. It was something other people cultivated as a diversion from the issues of real life.

While Adler probed the nature of man, he was far from being the man of nature. "I have never done anything more athletic than crossing the street," he once boasted. Hutchins, when queried about his disaffection for sports, quipped: "I get my exercise being pall-bearer for my athletic friends."

Walter Paepcke embraced skiing, but only as a business. Skiing, he surmised, would furnish a pleasant distraction for seminarians and help financially support Aspen's loftier pursuits. It was the mind that consumed him, and he was driven to make Aspen reflect that.

While Stein Erickson was performing flips on skis at Aspen Highlands, Aspen's brain trust was mired deep in the folds of gray matter in conference rooms at the Aspen Meadows campus. Aspen's destiny, they decided, would be as a cultural center where people came to think, listen to beautiful music, and study the humanities. One magazine caught the prevailing mood of Aspen with the 1951 headline: "BRAIN SPA."

While the pure pursuit of the mind in Aspen today isn't what it was in 1950, it has not been abandoned. Paepcke's direct contribution survives him in the Aspen Music Festival, the International Design Conference, the Aspen Institute, and the Aspen Center for Physics. The Great Books and Great Ideas programs, which came from Adler and Hutchins, are discussed here each year in informal community meetings

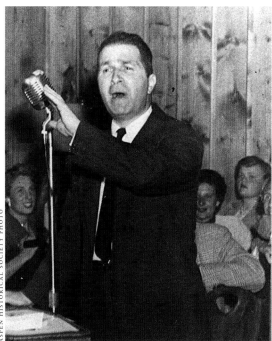

ASPEN HISTORICAL SOCIETY PHOTO

Mortimer Adler lectures at the Golden Horn restaurant.

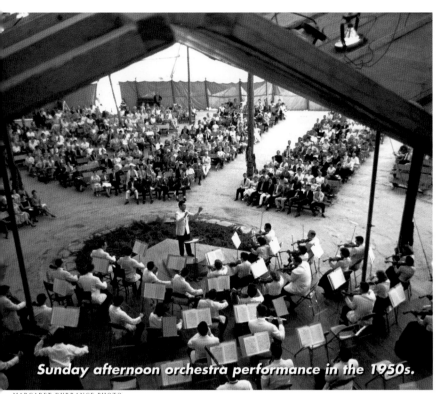

Sunday afternoon orchestra performance in the 1950s.

MARGARET DURRANCE PHOTO

led by volunteers whose passion is ideas.

On a summer day at the Aspen Institute's Meadows campus, toga-clad thespians wearing leafy garlands perform *Oedipus Rex* outdoors at Herbert Bayer's Marble Garden. In a nearby conference room the Institute's Domestic Strategy Group hashes over the future of the American workplace in the 21st century. The Program on Education in a Changing Society meets, as it has for 30 years, to debate education reform in America. A distinguished group of international journalists participate in the Catto Conference on Journalism and Society. The ongoing seminars that define the Institute's mission to groom leaders for "the good society" meet at traditional round tables.

From across the campus come the strains of the Aspen Festival Orchestra rehearsing a Prokofiev Piano Concerto. Next door, the Emerson String Quartet tunes up in Harris Concert Hall. Across town, the Aspen Opera Theater Center stages Verdi's *Falstaff* at the historic Wheeler Opera House. Across the valley, the Aspen Ballet Company warms up for a repertory performance. Music students from the Juilliard School, Oberlin College, New England Conservatory, Manhattan School of Music and other prestigious schools practice at the Aspen Music School on Castle Creek, in the dappled shade of aspen groves.

On Aspen's streets, guitar-strumming minstrels, string quar-

tets, and brass ensembles play for coins. Jazz and blues festivals have become major draws for Snowmass, where Anderson Ranch attracts international artists. Art is viewed in the Aspen Art Museum and in dozens of galleries. Sculpture is scattered throughout the city. Philosophical debates on growth, development and the environment are the usual fodder for city council, county commissioners, and planning and community groups attempting to plot a course for Aspen's future.

The values of the mind have been tested by the realities of resort economics and commercial success. Sprawl and congestion constantly conspire to overwhelm the essence of the Roaring Fork Valley's rural ambiance as the corporeal appetites of Aspen confound its more lofty goals and sentiments.

The future is rife with concern, and the valley's course is plagued by contention. Hutchins once described cultivated argument and dissension as a necessary route to truth: "The Civilization of the Dialogue presupposes mutual respect and understanding; it does not presuppose agreement . . . ," he said.

In Aspen, mutual respect for the magnificence of the mountains and valleys does not presuppose agreement on how to live in them. The future of Aspen spawns bitter debates about size, scale, ambiance and a host of abstractions referred to as "quality of life." One solution for preserving community character endorses "messy vitality," a kind of esoteric chaos.

Will a train serve the valley's transportation needs? A busway? An aerial tram? Golf carts? Horse and buggy? The bicycle? Is air quality reason enough to control emissions from cars, fireplaces, restaurants? Should limits be set on the size of "trophy homes?" Should rural areas be preserved from development?

Design, as participants in the International Design Conference of Aspen learn, is key to human progress—from community planning to the shape of the Aspen Music Tent. In Aspen, the

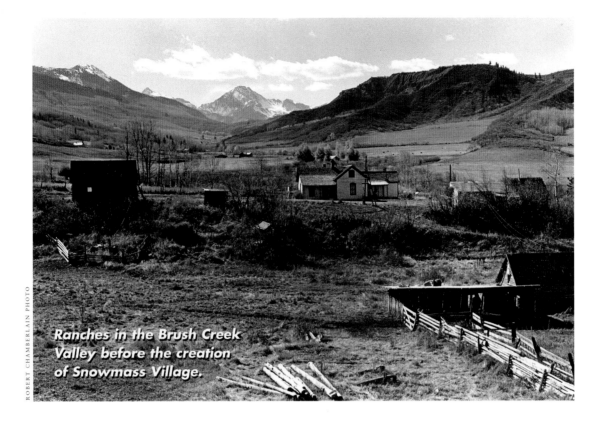

ROBERT CHAMBERLAIN PHOTO

Ranches in the Brush Creek Valley before the creation of Snowmass Village.

mind is more employed than ever in deciding the future of the city and the rural valley at its feet. And at risk of causing Aspen's former brain trust to turn over in their graves, the mind is also finely tuned to the pursuit of athletics.

Consider the mental focus of a downhill ski racer flying at 70 mph over a steep, icy race course, or the mental acuity of a golfer sizing up a long, uphill drive into a cross wind. The mind must facilitate the agility of a tennis player facing a tough opponent, the keen judgment of a parasailer plotting wind speed and thermal lift over Aspen Mountain, the instant reactions of a mountain biker navigating a technical section of single-track trail.

The mind, like the body, atrophies without exercise. Exercising both mind and body allows for a peak experience, a union of the mental and physical, a rare and elated fusion that approaches the spirit of THE ASPEN IDEA.

Herbert Bayer conceived that earth itself could be translated into sculpture. Anderson Park was

reated by the artist in 1971 to honor former Aspen Institute President Robert O. Anderson.

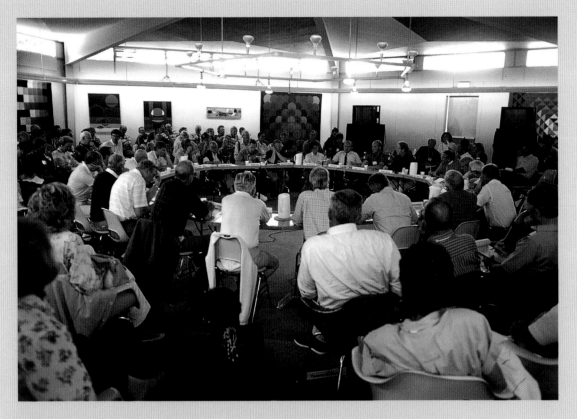

*The Aspen Institute conference rooms welcome a confluence of ideas—
intellectual, artistic, political, and scientific.*

Challenged by the complex issues of the day, thinkers and visionaries work to establish rapport and forge new solutions to age-old problems. That such work takes place in a valley shadowed by tall mountain peaks in a profoundly beautiful environment is the reason the Aspen Institute was founded in Aspen instead of Chicago.

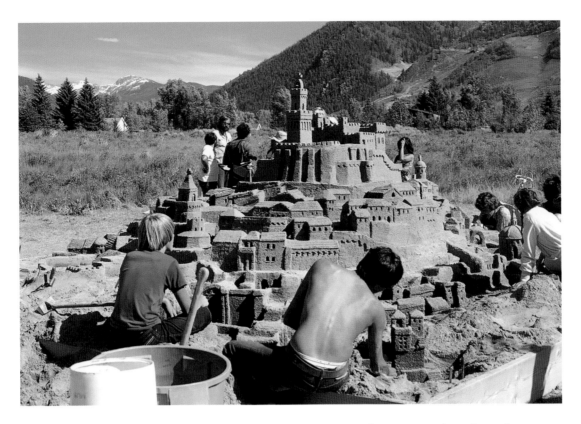

Castles made of sand form an Italian hill town at the International Design Conference at Aspen.

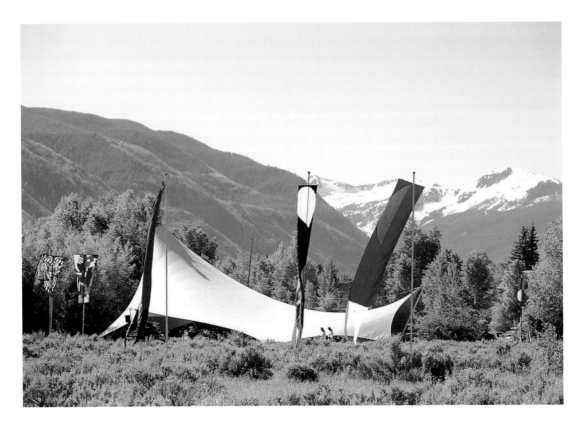

A Design Conference Japanese tent illustrates the pliant artistic potential of canvas.

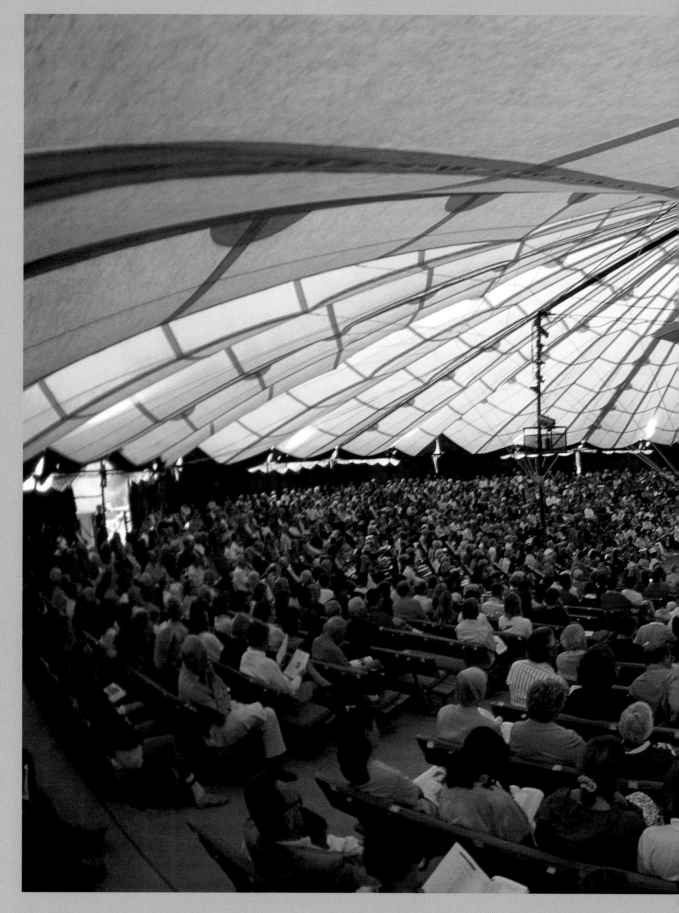

The Aspen Music Festival Tent, designed by Herbert Bayer and Fritz Benedict, brings world class

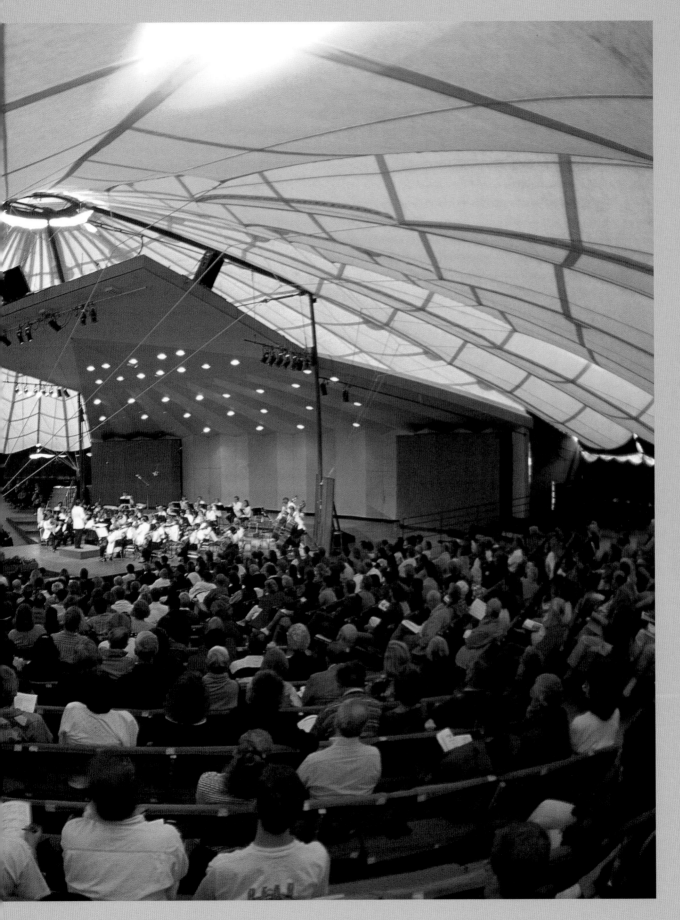

performances under the diffused light and protection of gently moving canvas.

Dinner is taken under canvas on the Hyman Avenue Mall.

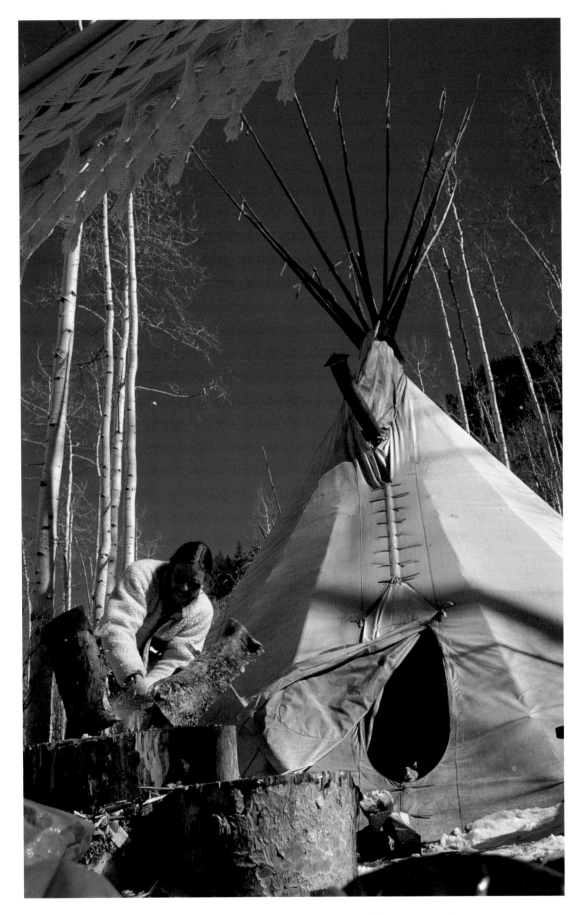

Teepee dweller Luke Nester prepares for winter in his canvas home.

Left **Aspen, first a tent city, was infused with Victorian filigree as façade became an important design criterion in the 1880s.**

Above **To others, façade was extraneous, as this funky house shows before its gentrification in the 1980s.**

In Aspen, mutual respect for the magnificence of the mountains and valleys does not presuppose agreement on how we choose to live in them. Aspen spawns bitter debate about size, scale, ambiance and a host of abstractions referred to as "quality of life." One solution for preserving community character endorses "messy vitality," a kind of esoteric chaos.

Aspen's downtown edifices, like the Elks Building, stand for prominence and permanence against mountains that first produced silver, later skiers.

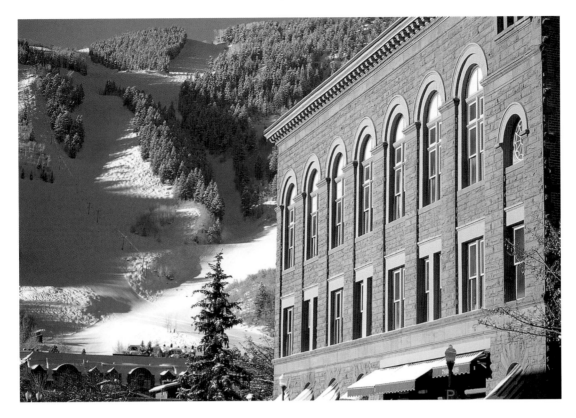

The Wheeler Opera House was built from Peachblow sandstone, a fundamental element of the earth from the nearby Fryingpan River Valley.

A starburst of light and form makes an abstraction of the theme-built Snowmass Village Mall.

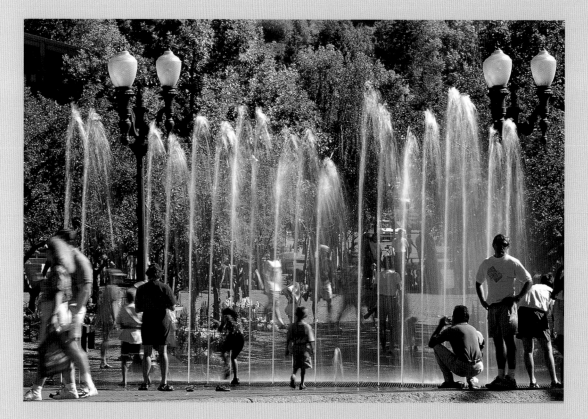

Above **The computerized fountain designed by Nick DeWolf on the Hyman Avenue Mall combines creative magic and cerebral ingenuity, all to the delight of sopping wet children.**

Right **The Pitkin County Courthouse (1891) is the seat of county government and a pronounced architectural focal point.**

Form follows function in Aspen where a fountain invites children
to soak themselves in intervals of water and sunlight.
Form makes the courthouse stand out as a magnet for the affairs
of local government and for the historic interests of visitors
and residents. Design puts the mind in charge of the body.

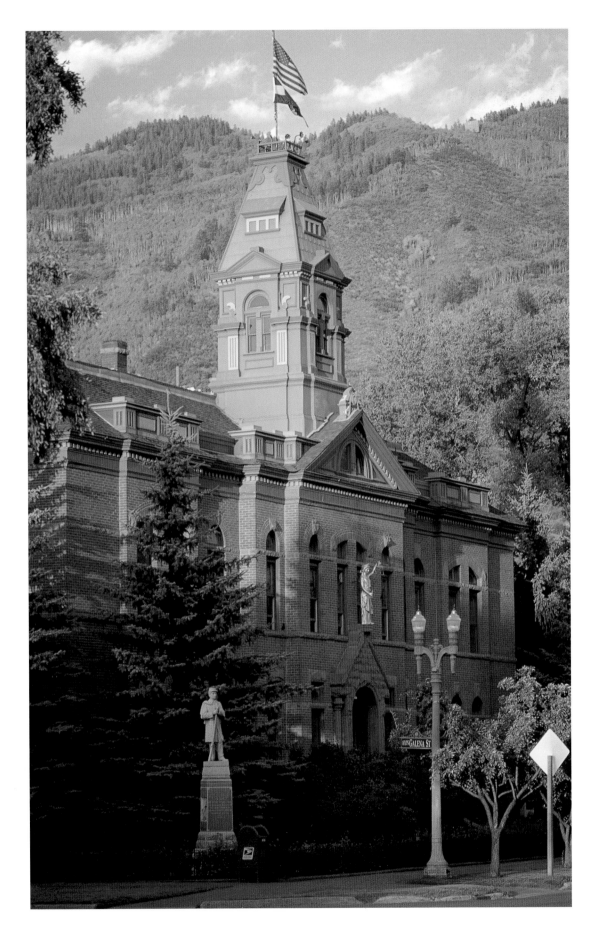

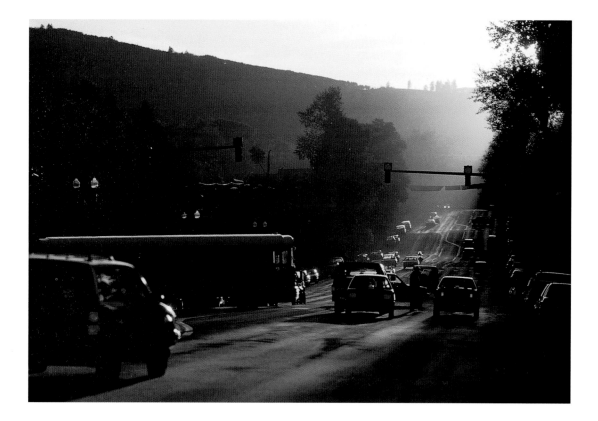

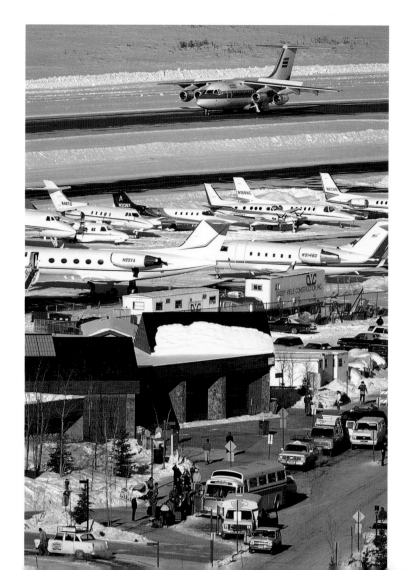

Above **One of the crucial problems created by the success of Aspen is traffic, where encouraging the use of bicycles . . .**

Left **. . . fighting gridlock and road rage on Main Street and . . .**

Left, below **. . . managing an airport crowded with private jet planes are pieces of the transportation puzzle.**

Sprawl and congestion constantly conspire to overwhelm the essence of the Roaring Fork Valley's rural ambiance. The corporeal appetites of Aspen confound its more lofty goals and sentiments. In Aspen, the mind is more employed than ever in deciding the future of the city and the rural valley at its feet.

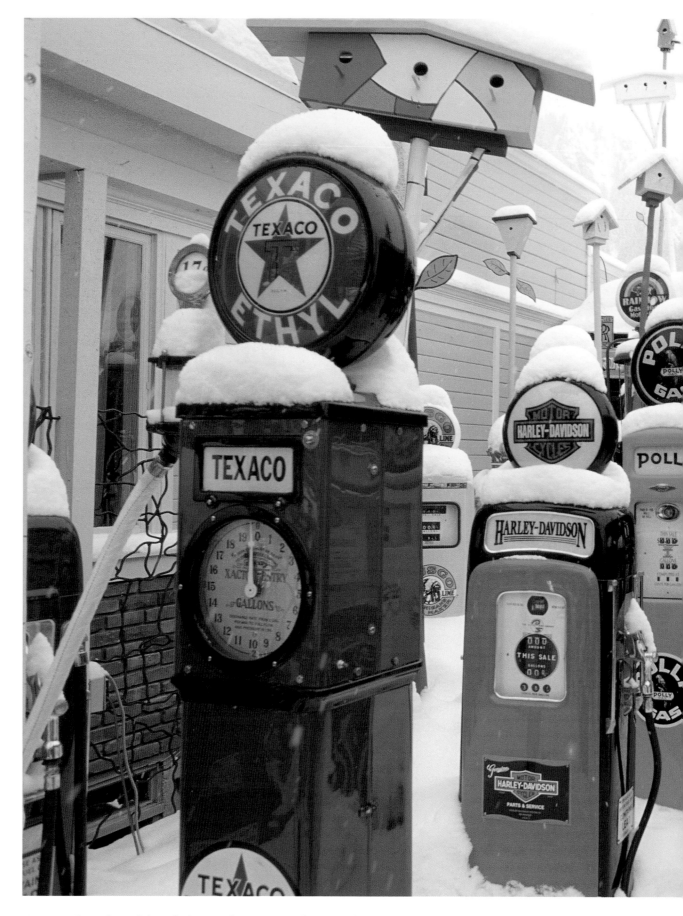

Our national and local dependence on oil is celebrated in a display of old-fashioned gas pumps.

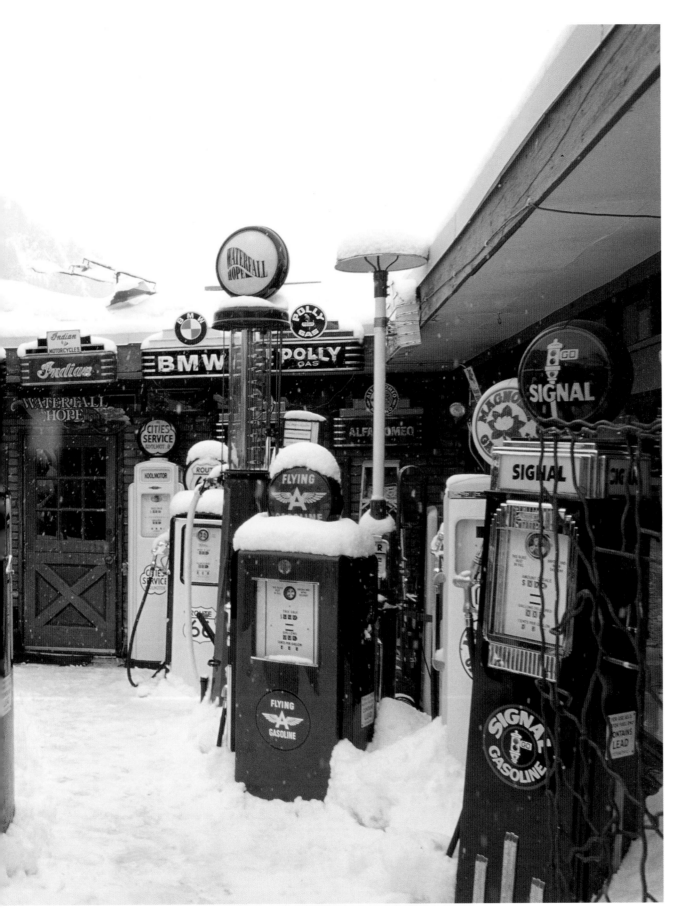

many of which find their way to Roaring Fork Valley homes.

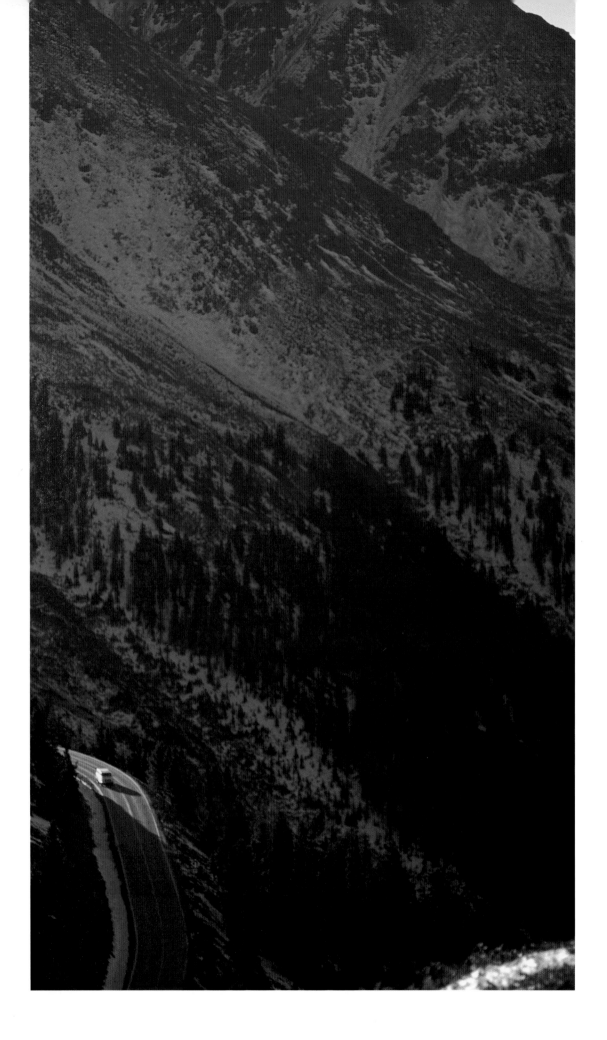

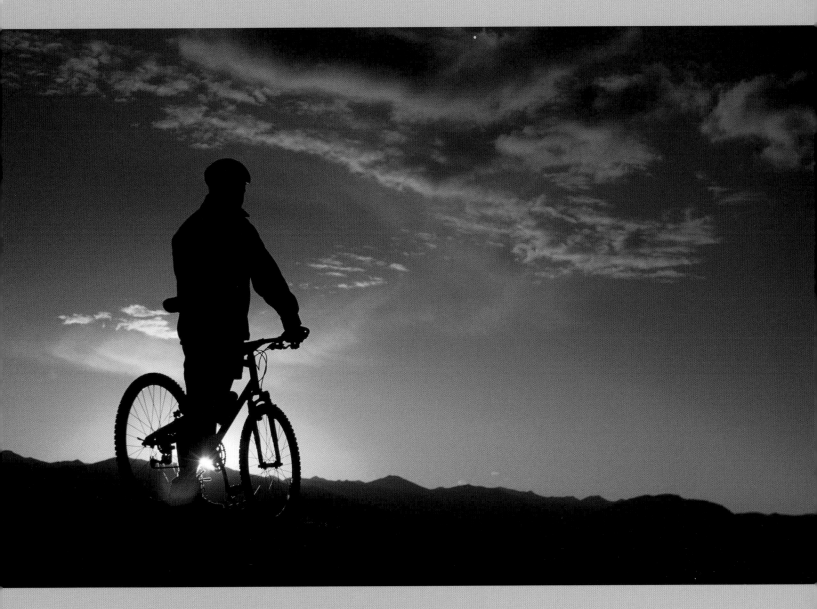

Left *The twisting pavement of Independence Pass offers escape and a sense of awe as it traverses through Aspen's scenic back door.*

Above *An old wagon road provides two-wheeled serenity on a high mountain ridge, where the world unfolds with the slow scan of an alpine horizon.*

Our mountains are not just a backdrop. They invite exploration, wandering, and an individual sense of discovery.

There is timeless tranquillity in a hay meadow blooming with dandelions on McClain Flats with Aspen Mountain in the background.

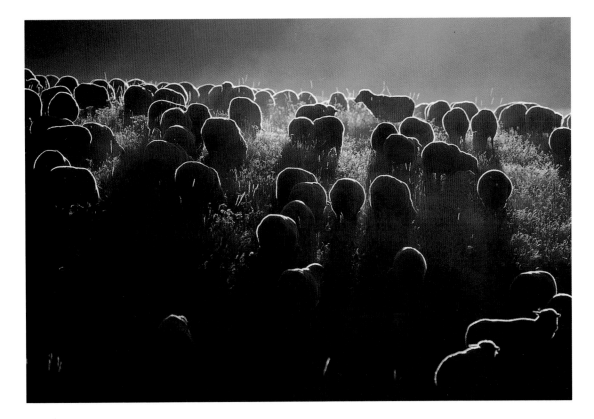

To the sheep farmer or cattle rancher, work constitutes a connection to the seasons and offers a contemplative link to the land.

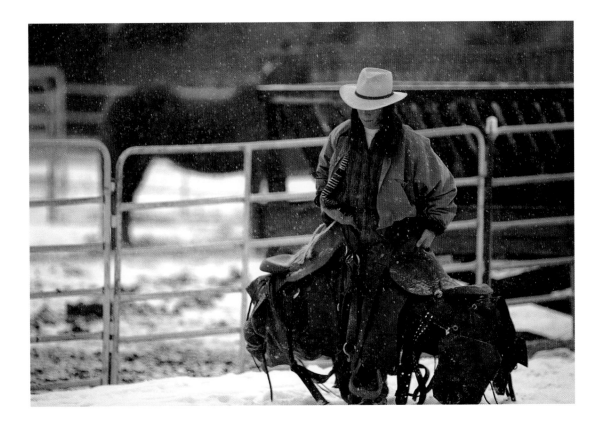

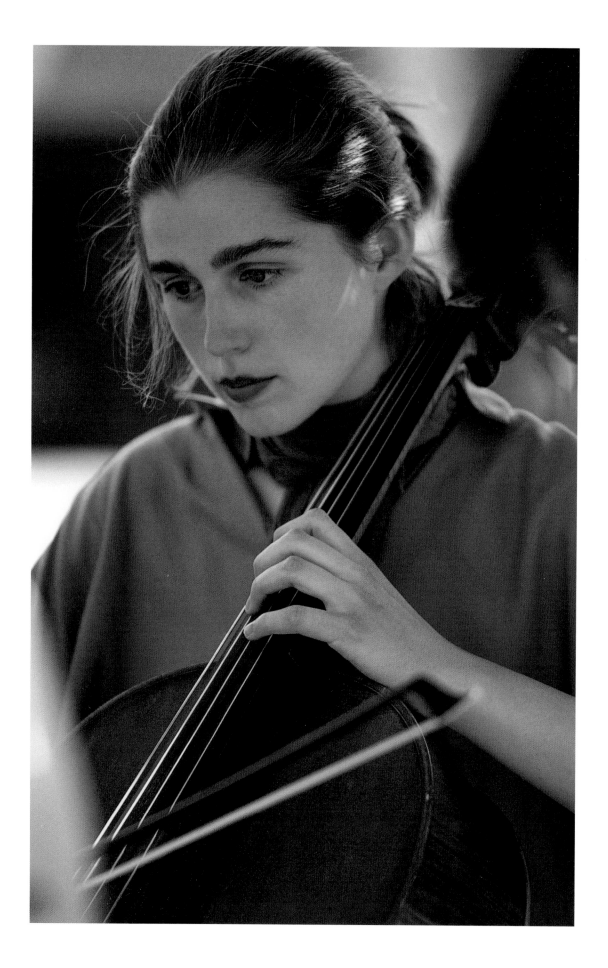

*"We are gathered here to search out in ourselves
the depths of the spirit that sustained Goethe..."*

—GOETHE FESTIVAL · ASPEN, 1949

THE GOETHE BICENTENNIAL FESTIVAL, A THREE-WEEK
convocation held in Aspen during the summer of 1949,
was predicated on spirit. The Festival—a blend of music
and dialogue—would stage a revival of humanism by
celebrating the ideals of two supremely eminent men—
German poet and dramatist Johann Wolfgang von Goethe
(1749–1832) and Dr. Albert Schweitzer (1875–1965), French clergy-
man, philosopher, physician and music scholar.

The event was an ambi-
tious undertaking even for the
visionary Walter Paepcke.
Daunting logistics and organiza-
tional snafus plagued festival
organizers. Aspen was a long
way from the cultural centers of
the world, and Goethe was no
household name. Attracting
musicians, writers, philosophers
and the renowned Schweitzer to
an obscure hamlet in Colorado
required a leap of faith.

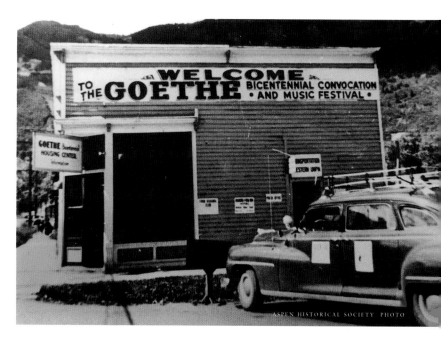

ASPEN HISTORICAL SOCIETY PHOTO

Held in the bleak shadow of World War II, in the face of
looming evils—totalitarianism, materialism, mechanization—the
Goethe Festival was part concert, part chautauqua, part camp

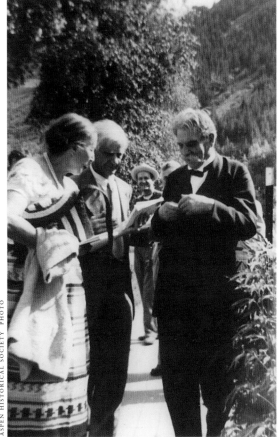

Albert Schweitzer (r.) at the Goethe Bicentennial, 1949.

revival. It was the inspirational prelude to a sweeping spiritual renaissance—or so organizers hoped.

The Festival Committee, led by Walter Paepcke and Robert M. Hutchins, was steeled to the task because the stakes were so high. Human culture was in a crisis, cautioned Hutchins: "Things seem to be bigger; they do not seem to be better. We are at last face to face with the fact that our difficulty is a difficulty of the human spirit. ..."

Aspen, cloistered deep within the Rocky Mountains, was fertile ground for idealism and spiritual renewal. Hidden from the world, unspoiled, serene and stunningly beautiful, Aspen would provide an attractive venue for transcendent philosophical dialogue. If the Goethe Festival succeeded, the picturesque town would become a center for humanism, a philosophy asserting the dignity and worth of man, his ultimate capacity for self-realization through reason, and his potential for good deeds through action.

The Festival would mark the 200th birthday of Johann Wolfgang von Goethe, who had called for nothing less than "a treaty of peace between the individual person and cosmic order." Albert Schweitzer, who represented Goethe as a near reincarnation, was one the greatest living humanists—a scholar, writer, musician and medical doctor who had dedicated his life to the poor and sick of Gabon, in West Africa, where he ran a bush hospital.

The Festival had a jubilant air during which the philosophical values of mid-century Aspen soared as high as its mountains. "The great society will not become the human community until it finds the common spirit that is man . . . ," extolled an early Aspen Institute writing. "We try here to undeceive and fortify ourselves."

The spirit that infused Aspen in 1949 was one of unimpeachable purity. With role models like Goethe and Schweitzer, there was no room for moral compromise. Aspen would lead a crusade for ethics and morality in the spirit of Goethe, by the actions of Schweitzer, and through the legacies of both men.

Goethe had ordained that man is morally obligated by a common spirit with all creation, all existence. "A man is ethical," agreed Schweitzer, "only when life is sacred to him—the life of plants and animals as well as that of his fellow men."

The spirit of idealism, however, proved as difficult to

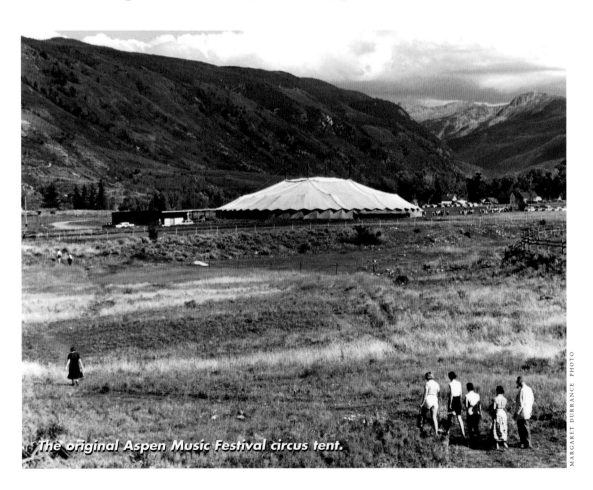

The original Aspen Music Festival circus tent.

maintain as Paepcke's utopian vision for Aspen. In an imperfect world, churned by modern dichotomies, idealism was doomed; utopia was a field of dreams.

The Goethe Festival remains Aspen's highest benchmark, a zenith in conscience and thought that lights the past with the glow of inspiration and optimism. The most lasting vestige of the Festival, however, is not ethereal. What brought the Festival to Aspen in the first place was the attraction of the venue, of Aspen itself. Today, finding awe in Aspen's sublime natural surroundings, charm in its historic facades, and rapture in its rich culture remains the most universal aspect of THE ASPEN IDEA.

In Aspen, one may discover the meaning of a Greek tragedy, hear the strains of a modern symphony, study a work of art, and later bask in reflections on a mountain overlook at the edge of an aspen grove, deep in the wilderness. The heart beats strong. The brain is oxygenated. The body is alive. The mind is enabled. The senses are keened. Perspective is achieved.

A 1948 black-and-white photograph of Herbert Bayer shows the Bauhaus architect perched atop a rock outcrop, overlooking the depths of the Maroon Creek Valley. Bayer is wearing a T-shirt, shorts, tennis shoes, and brimmed cap. His attire is casual, the setting dramatic. This is where Bayer may have been formulating his version of THE ASPEN IDEA, discovering its spirit in one of the greatest of all natural galleries.

Aspen's spirit is not only born of philosophy; it's a way of life. On an exceptional powder ski day on Aspen Mountain, former Olympic downhill racer Andy Mill had rampaged waist deep in powder snow all morning with a group of old friends from his Aspen high school days. "We are living large!" Mill enthused, suggesting a deeply gratifying experience. His spirit had been renewed that day on the mountain.

Spirit is a peak experience, a memorable moment when one

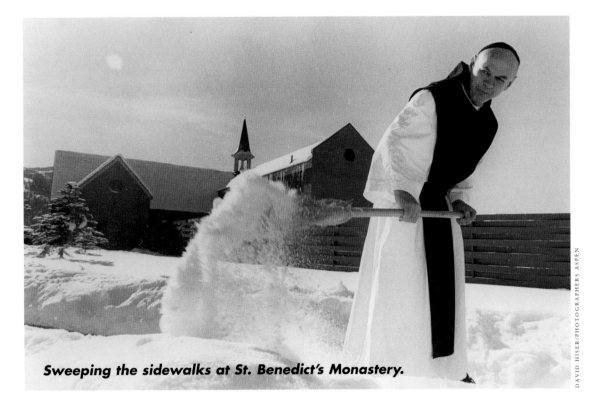

Sweeping the sidewalks at St. Benedict's Monastery.

is aligned with the cosmic order, when body and mind are one. Rock climbers, skiers, kayakers, cyclists, runners—all discover euphoria when their minds and bodies are in sync with the pulse of the world. Balance, agility, timing, awareness, all peak in a flash of inspiration—a clarifying moment of life.

Surrounding Aspen is a vast wilderness where immersion diminishes the distractions of the manmade world. Bird song, a rushing stream, the roar of wind in a spruce forest . . . these become the predominant sounds. The trappings of technology and the pressures of society are stripped away. The soul is exposed to the spiritual reservoir that nourished the Ute Indians, and later inspired many of John Denver's lyrics and environmental crusades.

When the spirit of life is tapped amid snowcapped mountain peaks, whitewater rivers, wildflower meadows, lush aspen groves . . . the experience is profoundly transcendent.

The spirit of THE ASPEN IDEA is about universal connections and commonality. We may not have the same political affiliations, the same skin color, the same background, but we share the

sublime beauty of a sunset, a rainbow, a waterfall, a mountain peak, a golden aspen grove quaking in a cool autumn breeze under a deep blue sky.

Spirit is expressed in the exuberance of mountain living. We find it in the solitude of a forest glade, in a dizzying free fall through deep powder, in the spectacle of a fireworks display over Aspen Mountain. Spirit lives in a pastoral landscape, a unique wildflower, the miraculous symmetry of a snowflake, the laughter of a child. Spirit lies in the capacity to synthesize our cumulative experiences into feelings of deep satisfaction and appreciation for a place, a time, and our belonging to it.

Johann Wolfgang von Goethe focused his faith on the human spirit—enlightening, uplifting and reshaping that spirit. In Aspen, we have personal growth workshops: Windstar's "Choices for the Future," Native American sweat lodges, communion at St. Mary's Church, the ritual chanting of Tibetan Buddhist monks, the Concert for Harmony, a sunrise mass at St. Benedict's Monastery, an impromptu drumming session in a Castle Creek teepee.

Goethe questioned the industrial, not wanting to live by the clock or the machine. He preferred unregimented, non-conforming, not anonymous or impersonal scale. Goethe saw the human being as a manifestation of the supreme spirit, the source of life.

Aspen represents a connection with that spirit, a small pocket of human culture and human scale in an expansive wilderness, an interface for man and nature where the body and mind are free to achieve excellence, strive for unity, sample the well-spring of idealism. The spirit of Aspen grows from an idea celebrated in 1949 that still leads active, thinking people to vaunted ideals.

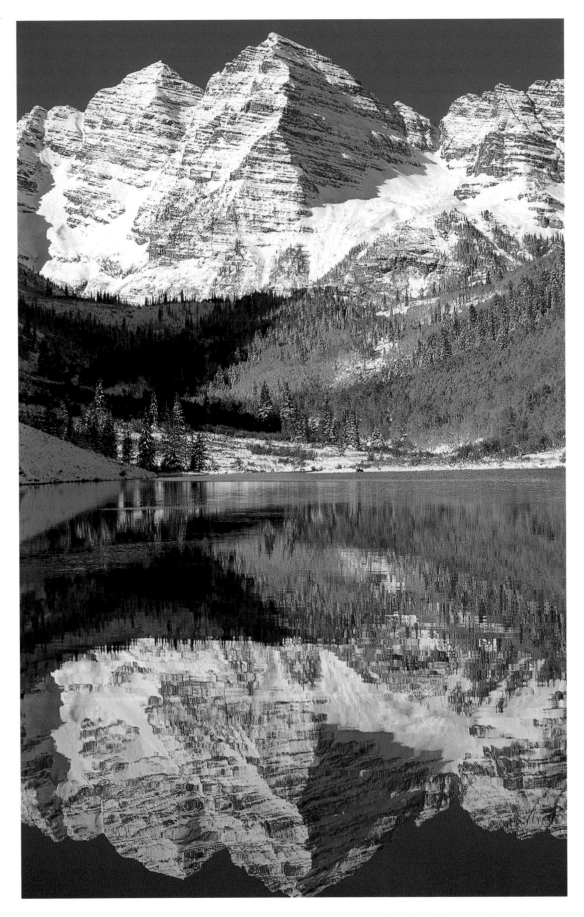

Spiritual renewal in a pantheist's paradise means cathedral-like settings in every fold of the mountains, in this case the justifiably famous Maroon Bells.

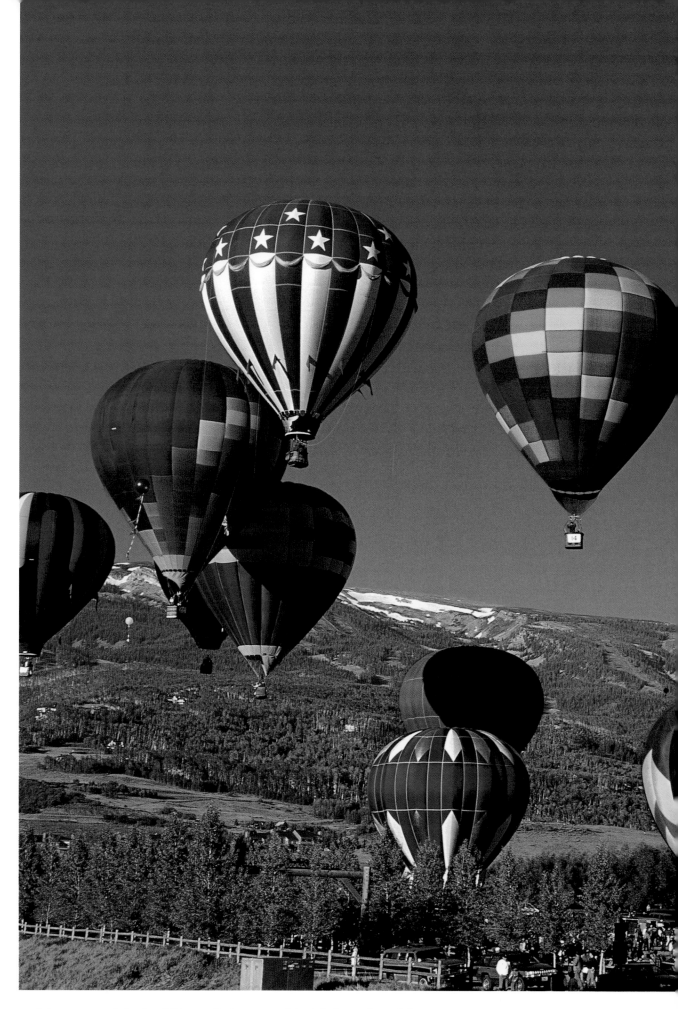

Spirits soar with the lifting of dozens of brightly colored hot air balloons from the Rodeo Ground

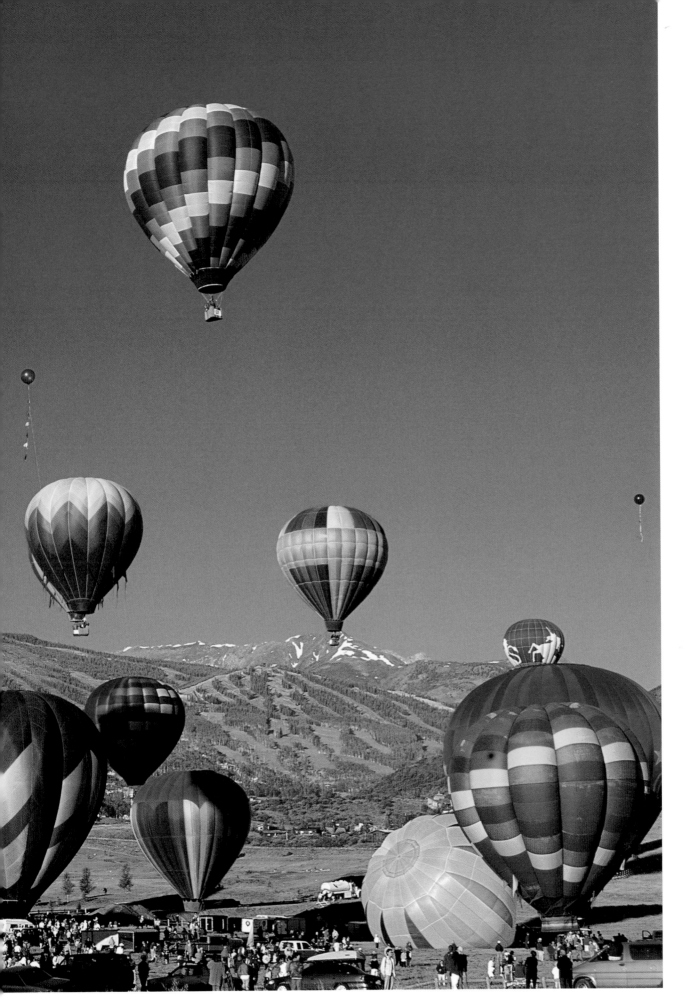

the annual Snowmass Balloon Festival.

Nature's varied palette splashes meadows at Ashcroft with brilliant fireweed, a robust wildflow

...ignifying renewal and hope in the wake of a forest fire or other disturbance to the land.

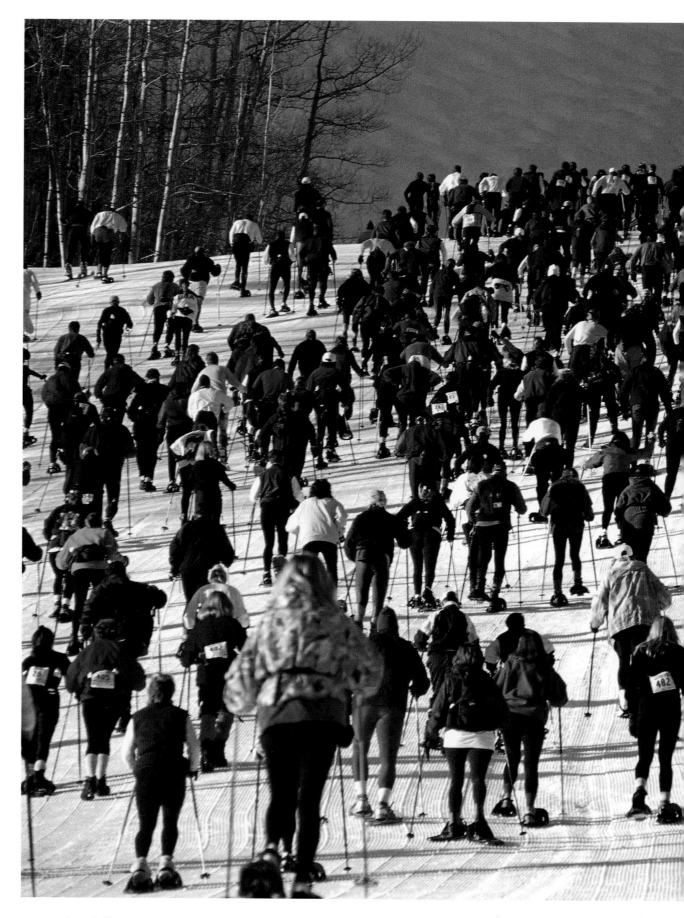

Annual uphill events spawn a communal energy that surges up the ski mountains in the spirit of

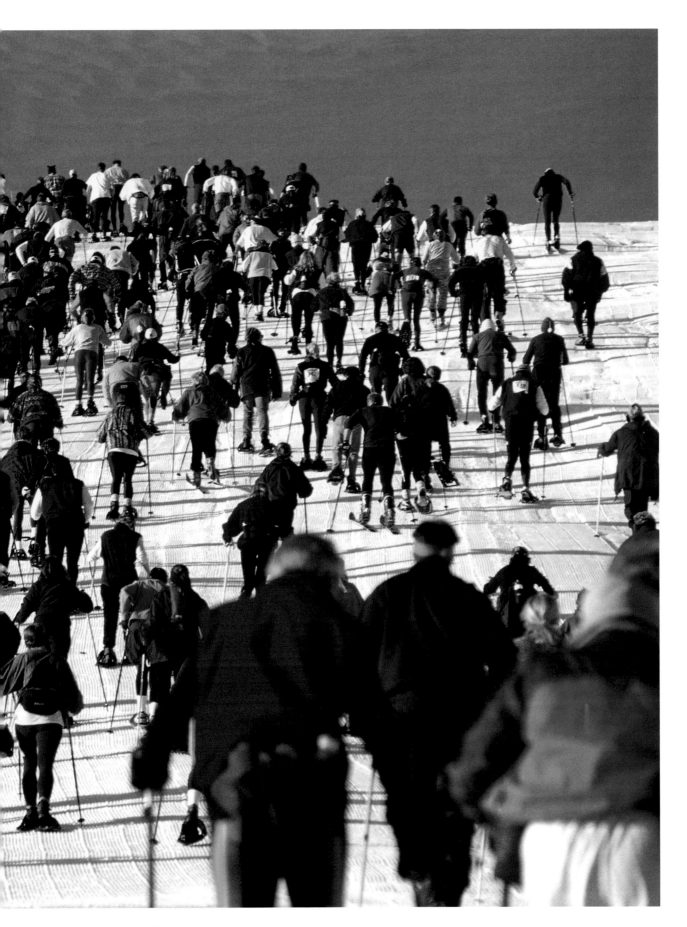

mpetition, personal effort, and mutual encouragement.

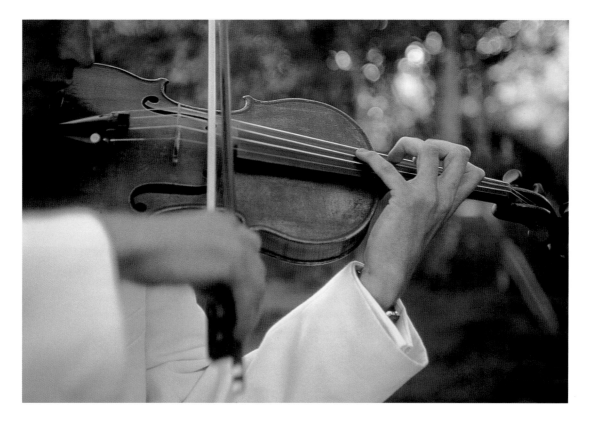

Above **Fine music provides an uplifting of the human spirit.**

Right **The beautifully proportioned steeple of the Aspen Chapel was inspired by French architecture of the Middle Ages.**

The performance arts are often touched by spirituality as human creativity resonates with a connection to a deep font of beauty. And when meteorological circumstances conspire to frame a landmark with a rainbow of colors, we sense magic in the air. These are among the uplifting expressions of spirit in Aspen.

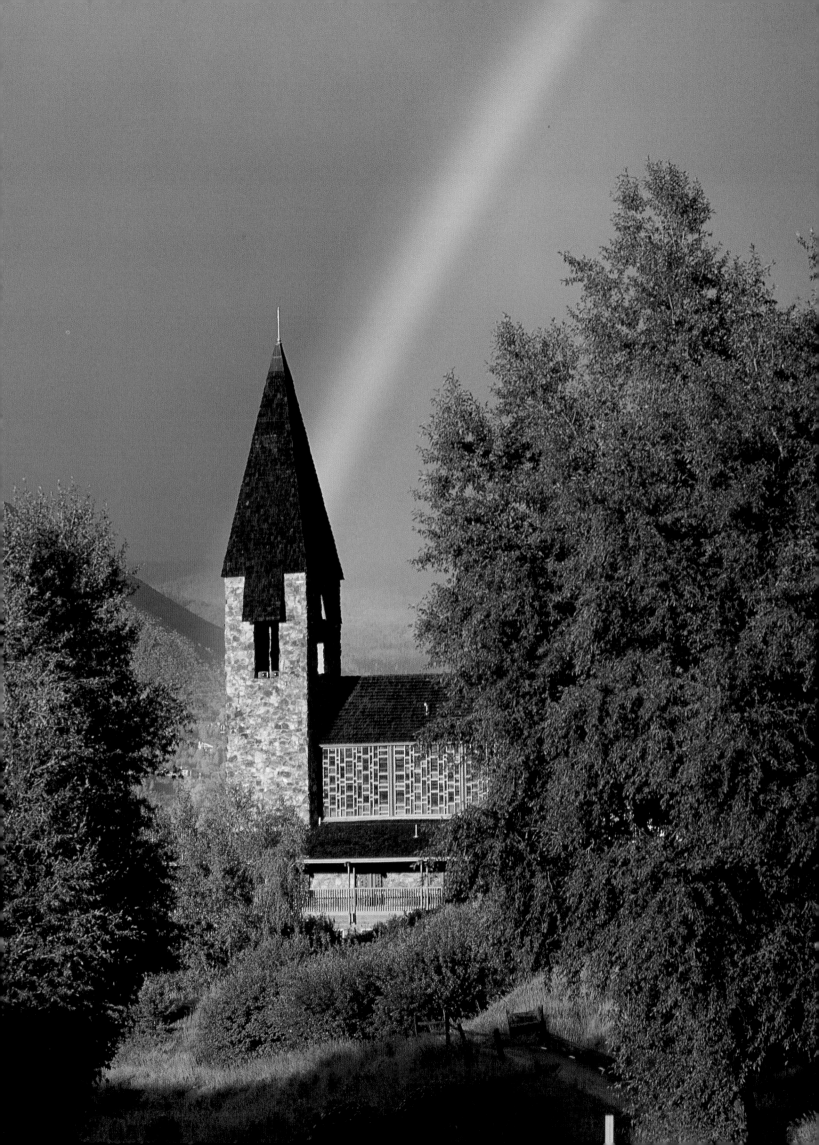

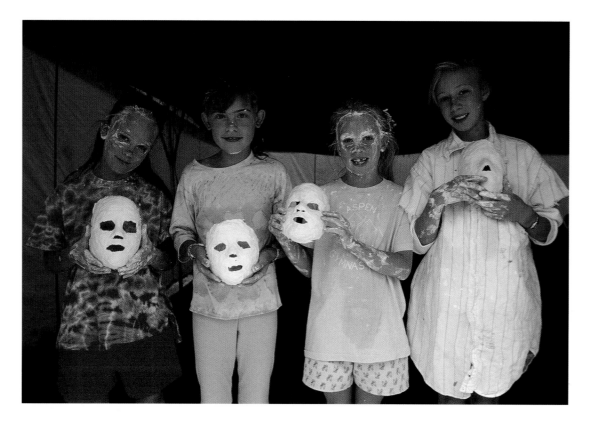

Spirit masks are fashioned by young artists at Anderson Ranch.

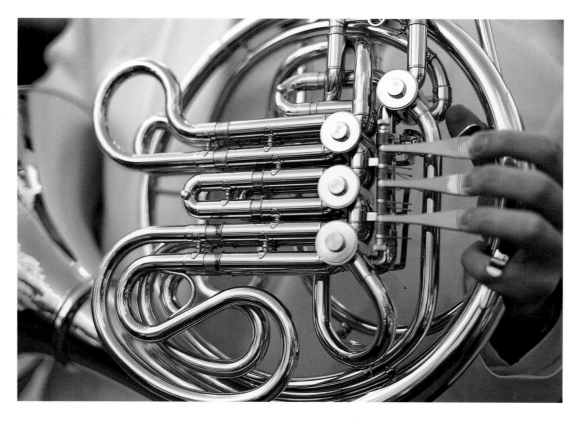

Commitment is required for the hard work and discipline of playing the horn.

A four-year-old violinist pauses on the campus of the Aspen Music School.

Above **The spirit of human interaction is fostered at Windstar in the Snowmass Valley ...**

Right, above **... while the interaction between humans and animals is explored by Aspen Center for Environmental Studies director Tom Cardamone and a flightless golden eagle.**

Right, below **Multi-cultural children at Windstar Foundation learn about the spiritual significance of a Native American sweat lodge.**

The spirit of THE ASPEN IDEA is about universal connections and commonality. We may not have the same political affiliations, the same skin color, the same background, but we agree on the sublime beauty of a sunset, a rainbow, a waterfall, a mountain peak, a golden aspen grove rustling in a cool autumn breeze under a deep blue sky.

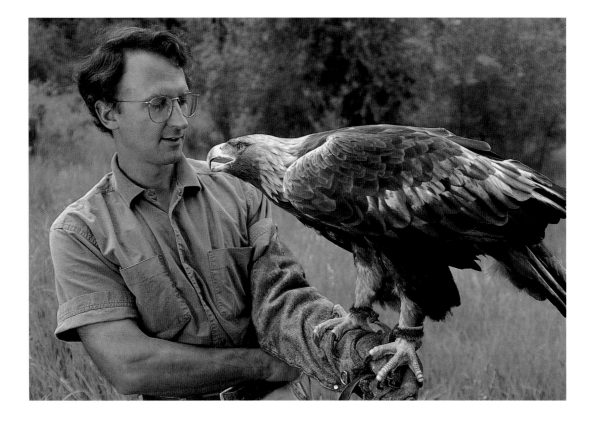

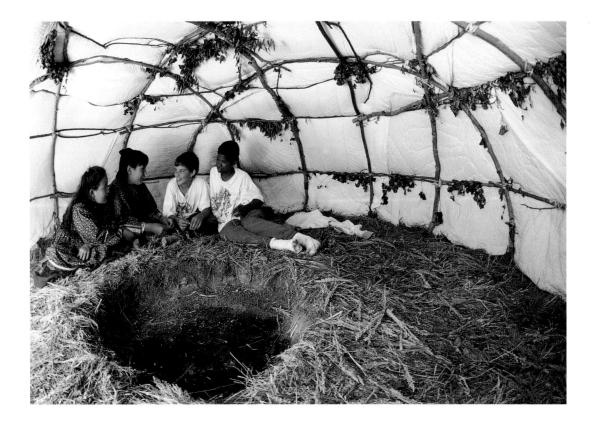

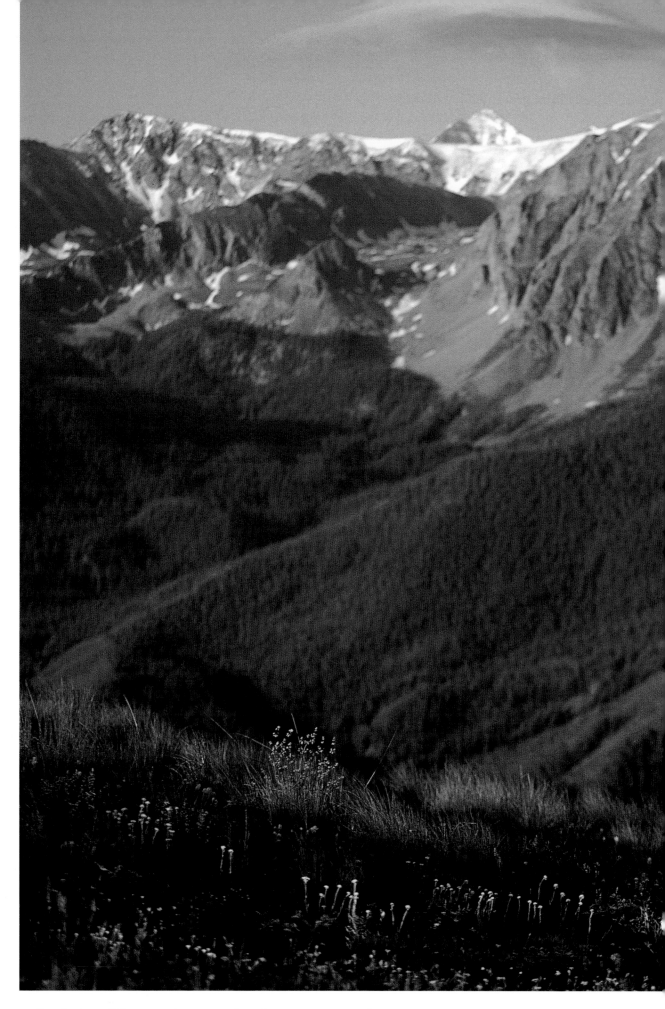

Solitude in wilderness is a sought-after experience for rejuvenating the spirit. Christin Cooper re

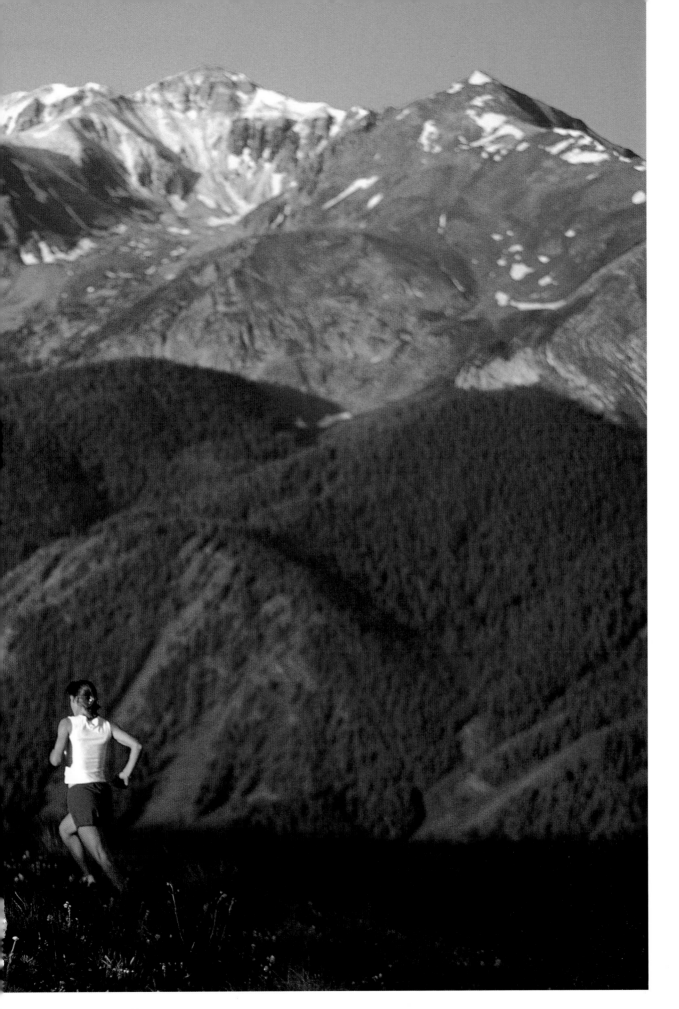

…he ridge of Aspen Mountain on a summer morning.

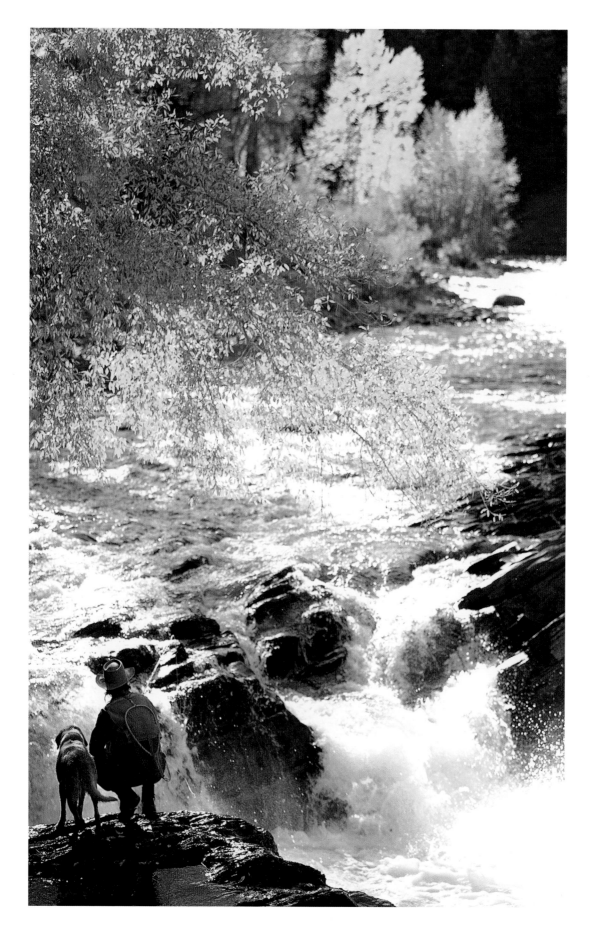

Above *Wading a rippling river, feeling the tug of a native cutthroat trout—the spirit of the fisherman is expressed.*

Left *Slaughterhouse Falls on the Roaring Fork River, tumbling through the canyon near the Rio Grande Trail, can be a marvelous antidote to stress and strain.*

Surrounding Aspen is a vast wilderness where immersion
diminishes the distractions of the manmade world.
Bird song, a rushing stream, the roar of wind in a spruce forest
…these become the predominant sounds. The distractions
of technology and the pressures of society are stripped away.

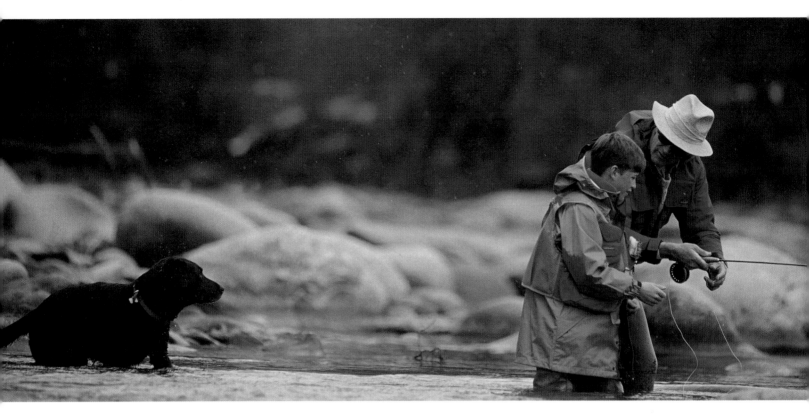

Spirited black labs and water are not long parted, even during a fishing lesson.

Dogs come in all shapes and sizes, as Mr. and Mrs. Gregory Peck demonstrate. Eager to lend a hand, "Gilligan" helps out on his first camping trip.

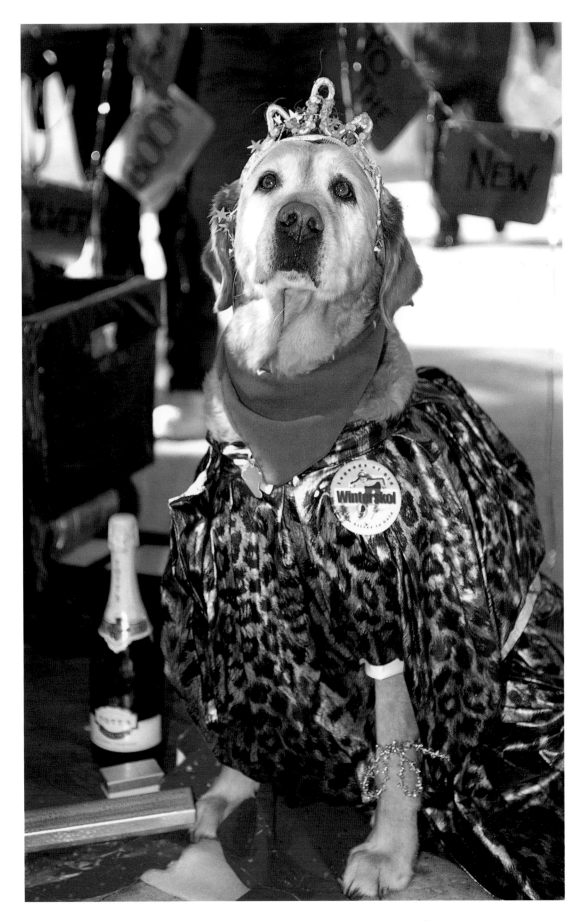

In the welcome spirit of levity, Cumi, Aspen's queen-for-a-day, is a crown-wearing golden retriever at Wintersköl.

Spirits are high as cheering crowds and a multi-day party captivate Aspen during Wintersköl.

Any excuse for a celebration—and in mid-winter, Aspen needs a community-wide blast.

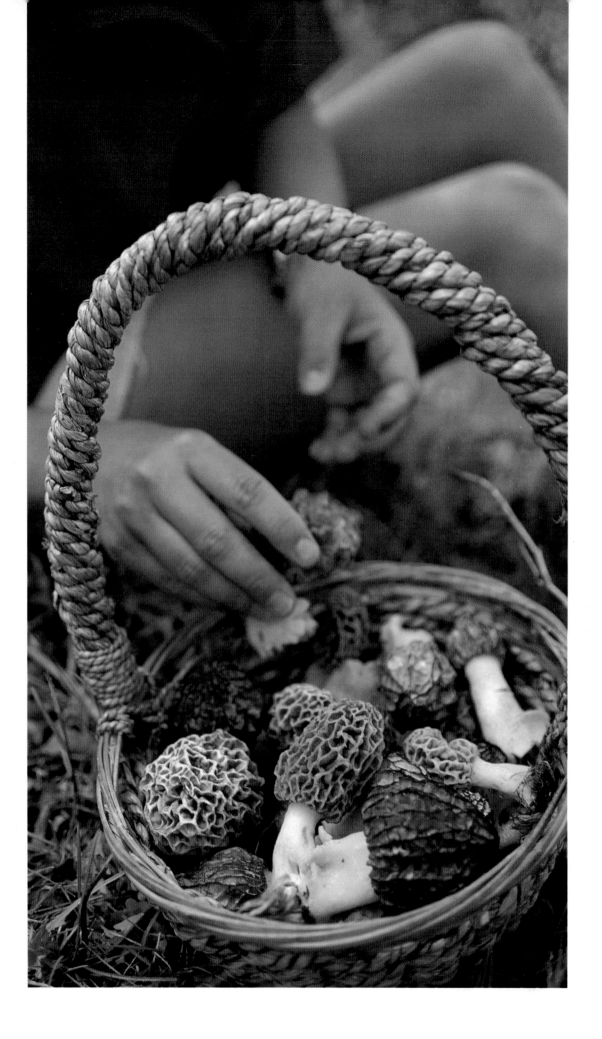

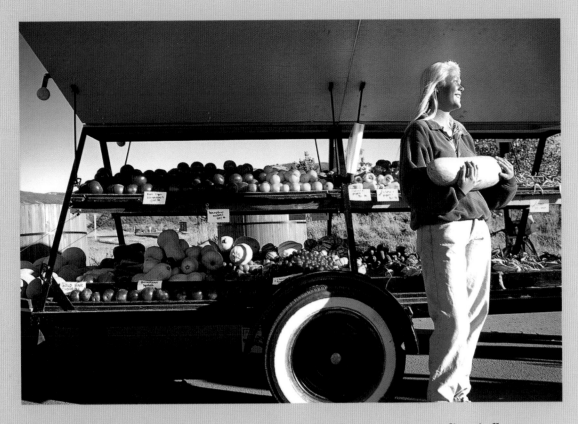

Above **For those who favor home grown produce as a grounding influence, the fruit and vegetable stand at Buttermilk is a panacea.**

Left **Discovery in nature and a treat for the palate are part of the mystique around mushroom gathering.**

Aspen's spirit is not born only of philosophy; it's a way of life.
Finding awe in Aspen's spectacular natural surroundings,
charm in its historic façades, nurture from its community,
and rapture in its rich culture remain the universal aspects of
THE ASPEN IDEA.

Colorful blooms complement an old mural as new life is given to the old on an alley in Aspen.

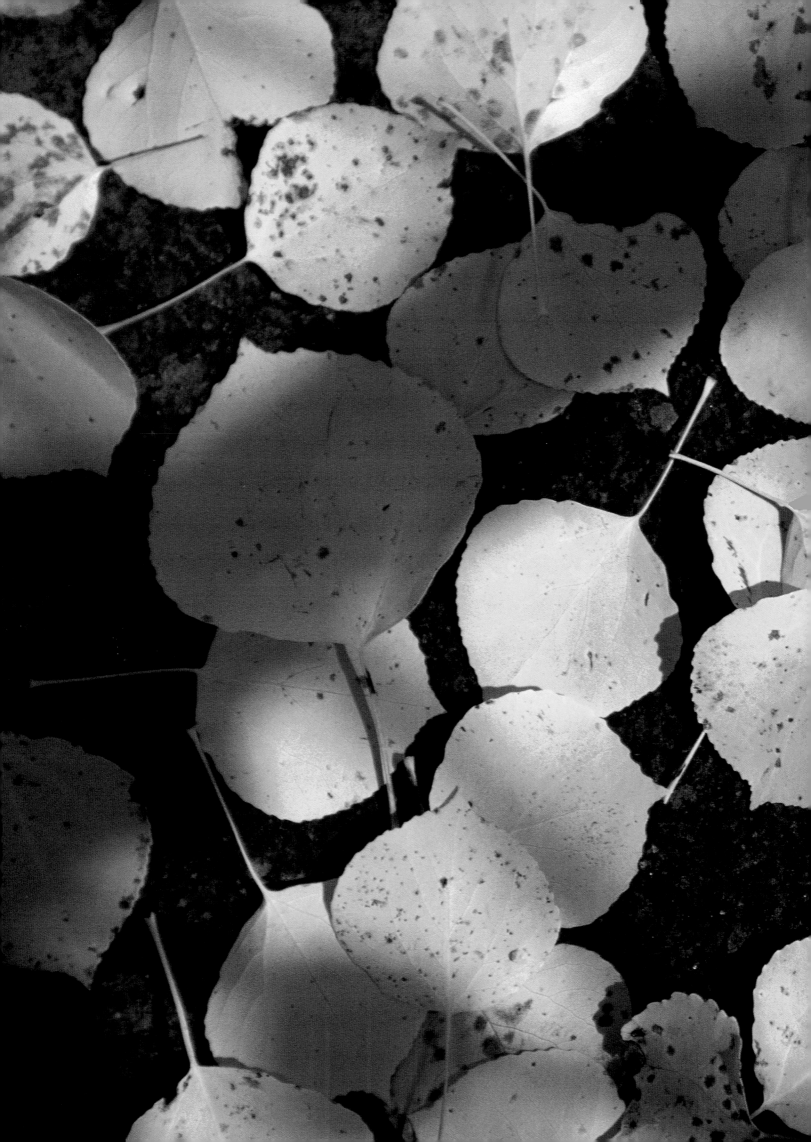

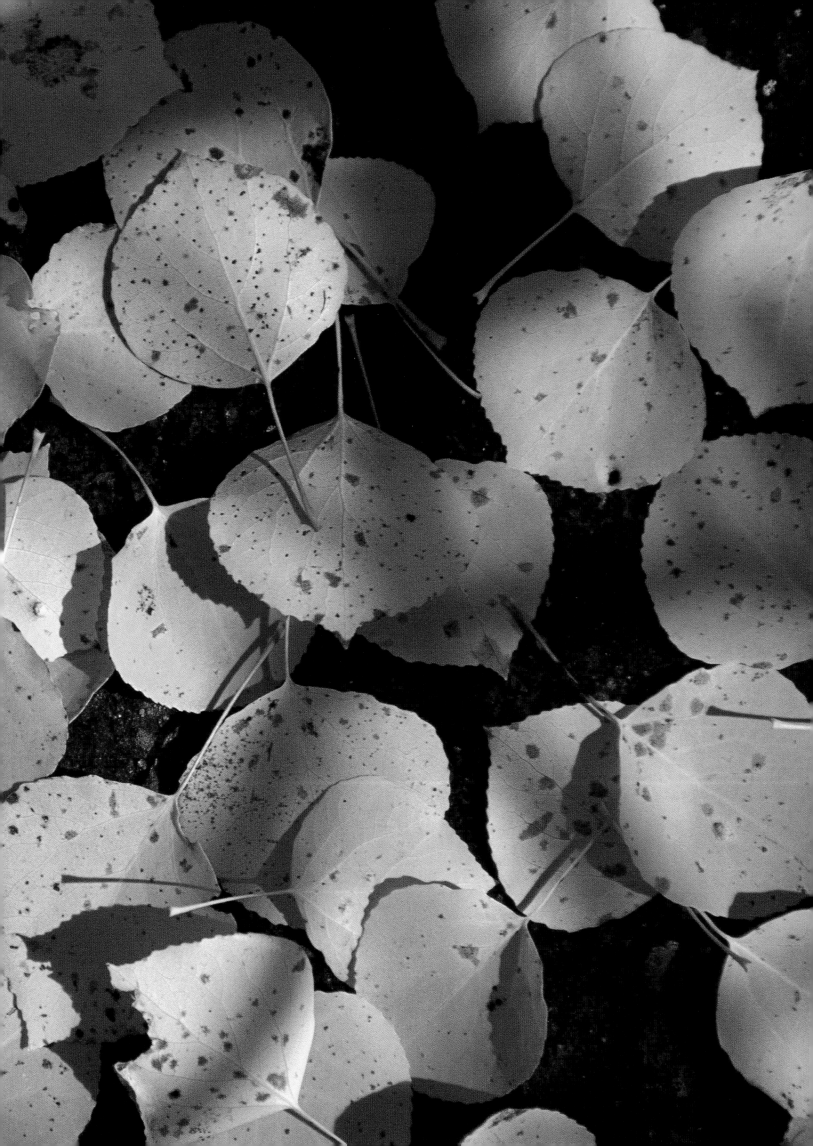

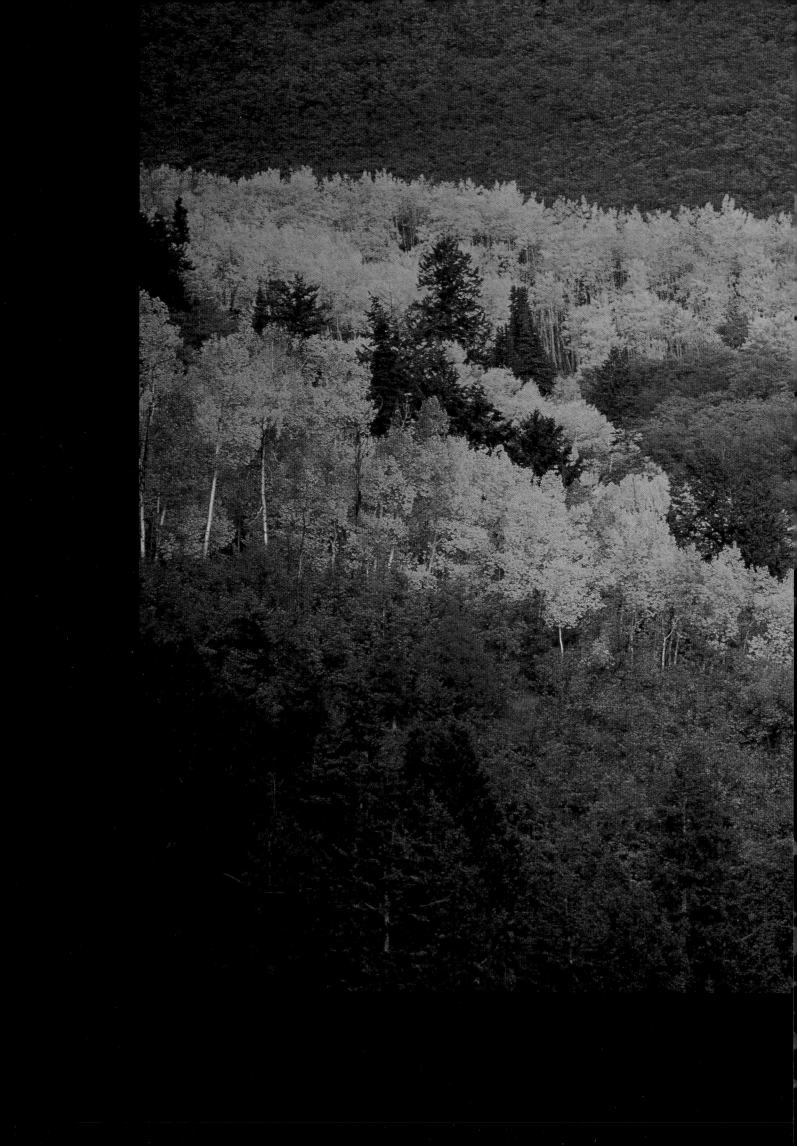

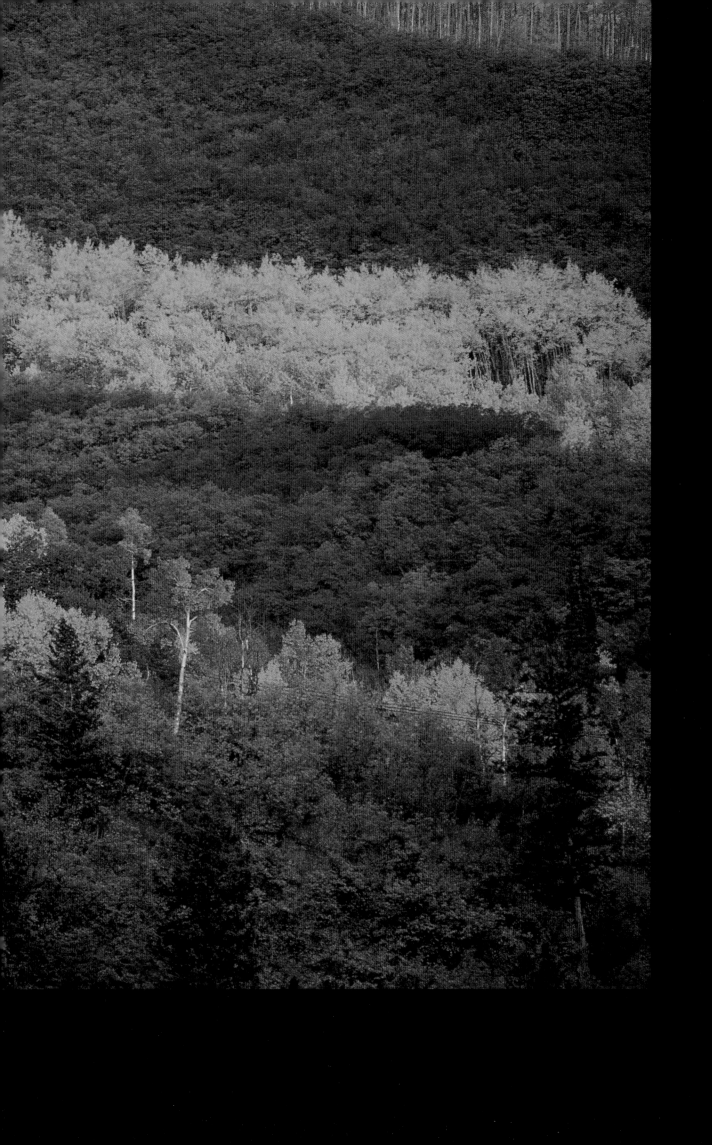

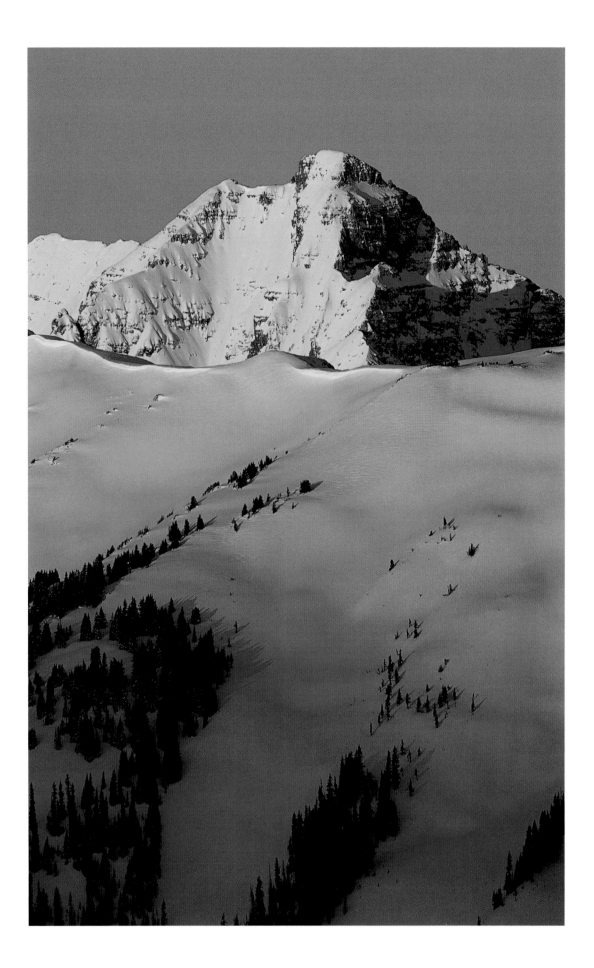